SITES OF IMPACT

SITES OF IMPACT
METEORITE CRATERS AROUND THE WORLD

STAN GAZ

with essays by Christian Koeberl and Robert Silberman

———

PRINCETON ARCHITECTURAL PRESS NEW YORK

Published by
Princeton Architectural Press
37 East Seventh Street
New York, New York 10003

For a free catalog of books, call 1.800.722.6657.
Visit our web site at www.papress.com.

Editor: Nancy Eklund Later
Designer: Paul Wagner

Special thanks to: Nettie Aljian, Sara Bader, Nicola Bednarek, Janet Behning, Becca Casbon,
Carina Cha, Penny (Yuen Pik) Chu, Russell Fernandez, Pete Fitzpatrick, Wendy Fuller, Jan Haux,
Clare Jacobson, Aileen Kwun, Linda Lee, Laurie Manfra, John Myers, Katharine Myers,
Lauren Nelson Packard, Jennifer Thompson, Joseph Weston, and Deb Wood of
Princeton Architectural Press —Kevin C. Lippert, publisher

Library of Congress Cataloging-in-Publication Data
Gaz, Stan.
Sites of impact : meteorite craters around the world /
Stan Gaz ; with essays by Christian Koeberl and Robert Silberman. — 1st ed.
p. cm.
ISBN 978-1-56898-815-3 (alk. paper)
1. Landscape photography. 2. Meteorite craters—Pictorial works. 3. Gaz,
Stan. I. Koeberl, Christian, 1959– II. Silberman, Robert B. (Robert Bruce),
1950– III. Title.
TR660.5.G388 2009 779'.36092—dc22
2008037544

Contents

Meteorite Impact Structures: Their Discovery, Identification, and Importance
for the Development of the Earth / Christian Koeberl

Between Heaven and Earth:
The Impact Photographs of Stan Gaz / Robert Silberman

Field Notes / Stan Gaz

───────────────── SITES OF IMPACT ─────────────────

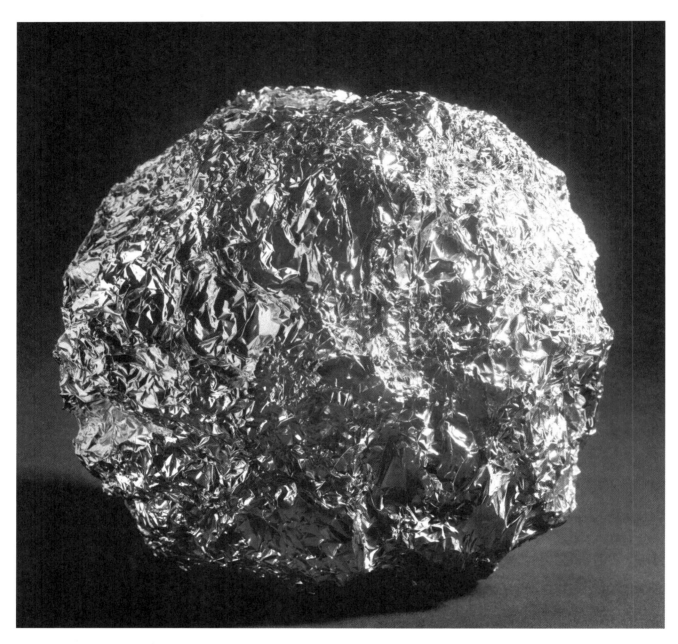

Meteorite, given to the photographer by his father

Acknowledgments

Making the photographs in this book would not have been possible without the love and support of my daughter, Kai, and my son, Keenan, who provide me with my inspiration in life and let me go so long without calling home. My mother, Maureen Gamel, and my brother and his wife, Kiernan and Amy Gamel, gave me great support and got me through some tough times, for which I'm very grateful.

Nancy Eklund Later and Princeton Architectural Press believed in my work and its viability as a book. Paul Wagner and Deb Wood applied their design and production expertise to create its unique package. Robert Silberman looked at my photographs and wrote about them in such a beautiful way. Christian Koeberl deftly situated the pictures' subject matter in the context of earth science. Geologists and space rock collectors, including Alan Langheinrich, Pieter Heydelaar, Debra Morrissette, Robert Haag (also known as "The Meteorite Man"), Bruno Fectay, and Carine Bidaut, graciously answered my questions while I carried out the project and prepared the book for publication. Charles Griffin, the most amazing artist and friend, masterfully printed the pictures. Brian Clamp of ClampArt graciously timed an exhibition of the work to coincide with this book's publication. Without the help of these generous people, this project would never have come to pass.

I would also like to thank a number of other people who have helped me along the way: my photography professor Tim Bradley, and my art and drawing professor Lorri Madden, at Art Center College of Design; John Bennett, who served as my own personal art consultant; Becky Ault, Mike Cunningham, and everyone at A.R.T.; Robin Lowe, Jenna Bischel, and Dave Lindsay at Art Crating; Tom Powel; Russell Floersch and John Cowey; Noah Wall, Emily Wall, and Nga Trang; Michael Mazzeo; Marisol Villanueva; Maggie Hadleigh-West, Linda Ross, Justine Brennon, Gilles Depardon, Dave Gaz, Cordy Ryman, Charise Isis, Bernard Kruger; my friends Andy, Teresa M. Signorelli, Adrienne Margolis, Sharon Blau, Eleanor B. Alter, and Jennifer Lombardo; Mary A. Bohnen, Steven Joseph Lee, Christopher Burke, and Jeff Hirsch at Fotocare; all the people who collect my work; Philip Glass, for his music, which kept me company while I was home in the studio working; and Buckminster Fuller, for his wonderful way of looking at the planet he called "Spaceship Earth."

This book is dedicated to the memory of my father.

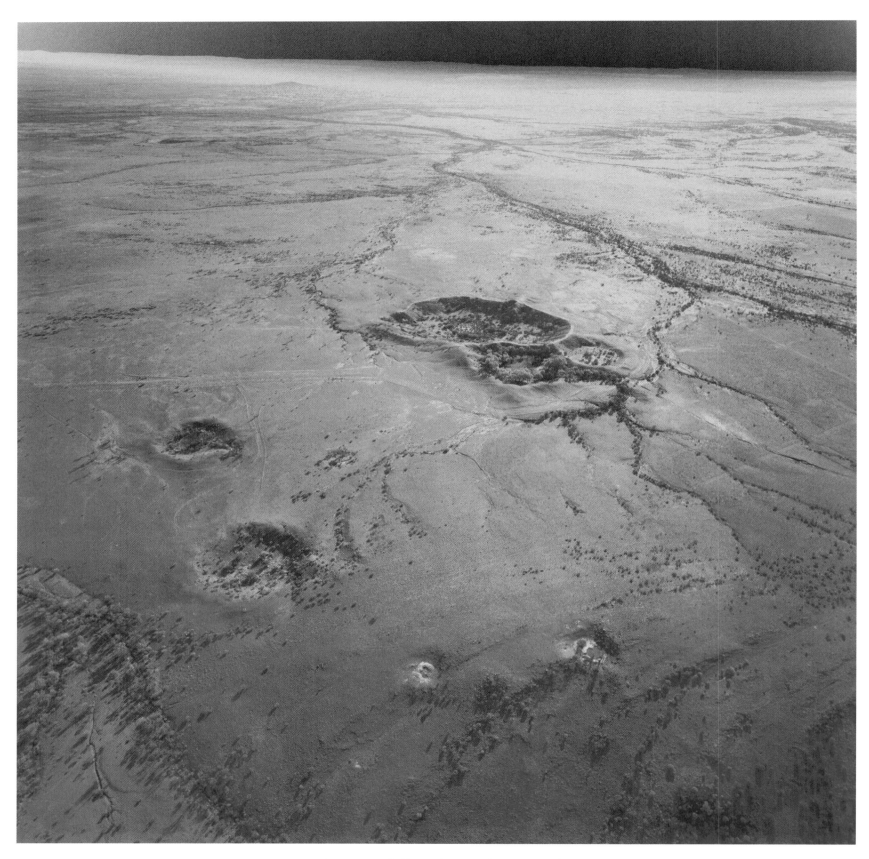

Henbury crater field, Northern Territory, Australia

Meteorite Impact Structures: Their Discovery, Identification, and Importance for the Development of the Earth

CHRISTIAN KOEBERL

Anyone who takes even a casual look at the moon can see that it is covered with craters. We now know that most, if not all, of these craters have been formed by a process called "impact cratering," in which a small body traveling at high speed slams into the surface of the moon, excavating a crater. Photographs of the surfaces of other planets, such as Mars and Mercury, reveal that their surfaces are also covered with craters, presumably formed by impact. On our planet, however, no such cratering is obvious when we examine aerial or satellite photos. On Earth, impact craters are an elusive landform. Why this is so, how we have come to recognize craters, and what their importance is for the geological and biological development of our planet is the topic of this brief essay.

———

The scientific investigation of impact craters began four hundred years ago. In 1609, the famous Italian astronomer Galileo Galilei (1564–1642) first pointed a telescope at the moon. He noticed circular spots and recognized, after studying the movement of shadows over a few days' time, that these features were not mountains but rather depressions on the moon's surface, some with central peaks. Galileo published the first drawings of lunar craters in his ground-breaking book of 1610, *Sidereus Nuncius* (The Starry Messenger), which set the stage for a true paradigm change in the natural sciences.

Galileo did not seem to have any specific opinion about the origins of the moon's craters, but in the centuries that followed, most astronomers were of the opinion that they had formed by volcanic processes, which were well known on Earth. The first scientist to speculate about the origin of lunar craters seems to have been the British physicist Robert Hooke (1635–1703). He considered the possibility that the craters had been formed by some sort of impact; to investigate this idea, he conducted a few crude experiments by dropping objects into mud. He noted that the resulting depressions looked similar to lunar craters. But after factoring in what was known at the time about interplanetary space—that it was considered to be empty—he concluded that impact processes could not have been responsible. In addition to Earth, astronomers knew of only seven objects in the solar system: the sun, the moon, and the planets Mercury, Venus, Mars, Jupiter, and Saturn. No minor planets or asteroids were known to exist.

At the dawn of the nineteenth century, all of this would change. The theory that meteorites existed and formed impact craters of an extraterrestrial nature, on Earth as well as on the moon and other planets, was given credence in the early afternoon of April 26, 1803, when thousands of meteorite fragments rained down on the town of L'Aigle, in northern France. After news of the fall reached Paris, the French Academy of Sciences sent the young astronomer Jean-Baptiste Biot (1774–1862) to investigate. His detailed and well-argued report describing how these stones must undoubtedly be of extraterrestrial origin effectively gave birth to the science of meteoritics.

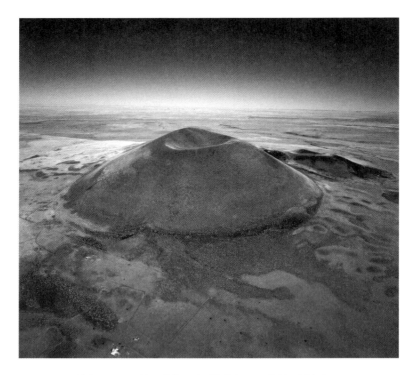

Volcano, north of Flagstaff, Arizona, United States

Still, over the next two hundred years, astronomers remained largely in favor of the theory that volcanoes and their related internal processes were responsible for crater formation. Only a few voices supported the impact theory. In 1829, Franz von Paula Gruithuisen (1774–1852) put forward his impact hypothesis. The credibility of the claim was not helped, however, by the fact that the German astronomer had announced a few years earlier that he had seen inhabited cities on the moon, complete with cows grazing on lunar meadows.

From the time of Galileo, the study of lunar craters had been pursued, for the most part, by astronomers. The few geologists who concerned themselves with lunar craters supported the volcanic hypothesis. The first geologist to engage in a serious study was Grove Karl Gilbert (1843–1918). In 1892, after carefully observing lunar craters and performing impact experiments in his hotel room during a lecture tour, he too endorsed the impact hypothesis. In 1921, the German scientist Alfred Wegener (1880–1930) published a little-known booklet in which he discussed his own impact experiments and presented his conclusions regarding lunar and terrestrial craters. But his views, like Gilbert's, went largely ignored.

In general, the geological community did not give much credence to the concept of impact cratering, on the moon or on Earth. In fact, geologists of the early twentieth century did not pay much heed to any violent, short-lived events. The "fathers of geology," James Hutton (1726–1797) and Charles Lyell (1797–1875), believed that slow, endogenic processes led to gradual changes in the geological record. Upholding their motto "the present is the key to the past," they maintained that geological remains from the distant past could only be explained by comparison with geological processes that were directly observable in the present. This uniformitarian view failed to take into account rare phenomena that could not be observed during

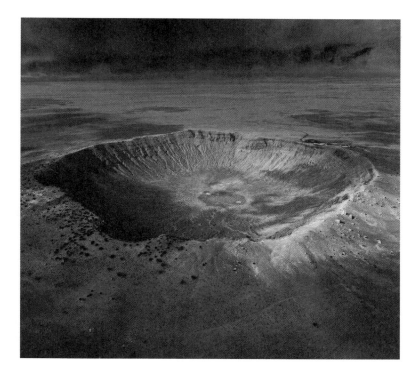

Meteor Crater, also known as Barringer Crater, Arizona, United States

human lifetimes. Impact—the colliding of two bodies in space—is a relatively rare, exogenic, rapid, and unpredictable event, and, as such, violated every tenet of uniformitarian thought. This may explain why many adherents to the Lyellian view of geology opposed the explanation of craters as being of impact origin.

The crucial events that set the stage for the acceptance of impact as the cause for even some terrestrial craters took place in central Arizona, at a place called Coon Butte, or Crater Mountain. This crater had come to the attention of Gilbert and other leading geologists because a large number of iron fragments were found in the area. These fragments turned out to be iron meteorites. The absence of meteorite fragments within the crater itself, however, together with the nearby presence of volcanoes, convinced researchers that Coon Butte was just a volcanic feature (formed by some sort of steam explosion, they speculated, as no volcanic rocks were exposed at the crater either). The meteorites must have landed in the vicinity by chance.

Confronted with the same evidence, mining engineer Daniel Moreau Barringer (1860–1929) came to a different conclusion. He felt sure that there was a connection between the crater and the meteorite fragments. Barringer grew convinced that the crater had been formed by the impact of a large iron mass, the main body of which was buried beneath the crater floor. He acquired the land rights to the entire crater area and embarked on a search to locate the meteoritic deposits. His plan was to then exploit the deposits for their rare metals, such as nickel, cobalt, and platinum-group elements.

From about 1903 until his death in 1929, Barringer searched in vain for the massive iron meteorite. He did, however, find something interesting beneath the crater floor: breccia, rock consisting of a fine-grained matrix in which fragments of other rocks are set. This breccia

contained the rock types that occurred in the area, but chaotically and violently mixed rather than layered in an orderly fashion, as they were outside the crater. Many small particles rich in iron and nickel were also found within the breccia, but no large solid body was ever found. The work of Barringer and his associates provided the first detailed geological study of the impact structure (renamed Meteor Crater by its owner), but ironically, some geologists became even more convinced that impact had nothing to do with the crater's formation, given their failure to unearth the large meteorite.

Halfway around the world, some important research demonstrated for the first time that, due to the very high velocities at which meteorites travel, impacts are similar to explosions (and therefore, regardless of the angle at which they collide with the moon or Earth, the resulting craters are always circular). Unfortunately, this discovery, made by Ernest Öpik (1893–1985) in 1916, received little attention, as the young Estonian astronomer published his findings in Russian, with a French abstract, in a little-known Estonian journal. The wheel was reinvented again in 1919 by physicist Herbert Ives (1882–1953), who noticed the similarity between lunar craters and pits formed by grenade explosions during the First World War. His work was similarly ignored. It took a third attempt, by the New Zealand astronomer Algernon Charles Gifford (1861–1948), who published his findings in 1924 and 1930, in English, in a more widely read journal, to finally convince astronomers and physicists, if not geologists, to take notice.

The works of Öpik, Ives, and Gifford also caught the attention of Barringer's astronomical advisors. The logical, if inconvenient, conclusion to be drawn was that there was no problem explaining both the impact origin of Meteor Crater and the absence of large amounts of meteoritic material. Given the high velocity with which a large meteorite hits the ground (between 11 and 72 kilometers per second, following celestial mechanics), a large amount of energy is released somewhat below the Earth's surface, and large quantities of rock are displaced. As a consequence, a crater ten to twenty times larger than the diameter of the meteorite is typically formed. Barringer had a difficult time accepting that his basic premise—that a meteorite was hiding underneath the crater floor—had been invalidated and that his prolonged search had essentially been a wild goose chase, which had wasted years of his life and cost him a fortune to pursue. Soon after coming to this realization, he died of a heart attack.

If the early work by Barringer and others at Meteor Crater laid the foundation for a detailed understanding of impact cratering, the impact hypothesis nevertheless remained in its infancy, with opposition continuing right up until the time of the first manned landing on the moon. Planetary exploration and extensive lunar research eventually led to the conclusion that essentially all craters visible on the moon (and many on Mercury, Venus, and Mars) were of impact origin. From these observations, the fact that Earth had been subjected, over its long history, to a significant number of such events was finally established. Geologists resisted this conclusion due to the apparent absence of a large number of craters on the Earth's surface. But during the second half of the twentieth century, scientists increasingly acknowledged the power of Earth's active geological and atmospheric processes—explosive volcanism, earthquakes, massive floods, landslides, and erosion—to effectively obliterate the surface expressions of these structures. In contrast, for more than three billion years the moon has not been subjected to any internal processes that would have modified its surface. Compared to the Moon, Earth is an unreliable recorder of impact processes. Most of the very large and very old craters have

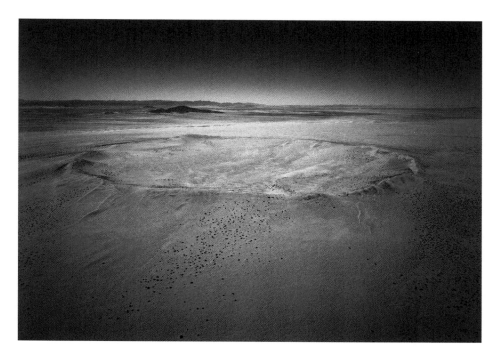

Roter Kamm, Namibia, a highly eroded impact structure

already faded from view, due to erosion, sedimentation, and the like. In a few million years, examples such as Roter Kamm in Namibia will probably disappear completely.

What we now realize is that geology is the result of a large number of individual catastrophes of various magnitudes, taking place over a sufficiently long period of time. These events, which create local devestation lasting on the order of a number of days to one hundred years, are part of the global "uniformitarian" process. The bias in what had been considered significant in the uniformitarian history of the Earth stemmed from its focus on human, rather than geological, time. Because large meteorite impacts had not been directly observed during the last few millennia, such events tended to be neglected.[1]

Today, astronomers and geologists recognize that impact processes are among the most common mechanisms to have shaped the Earth. Impacts that form craters of about 1 to 2 kilometers in diameter (the size of Meteor Crater) happen every few thousand years; those that form craters of about 20 kilometers in diameter occur several times per million years. This recognition has led to the acceptance of a new paradigm in terrestrial geology, which maintains that the geological evolution of Earth is not only influenced by internal or surficial geological processes but also by external, highly energetic ones.

————

[1] Ironically, small meteorites have been observed to fall from the sky quite frequently, but scientists have failed to make the connection to catastrophic impact events by applying the same principle used to extrapolate the frequency of volcanic eruptions and earthquakes: namely, that large and devastating events occur less often than small ones.

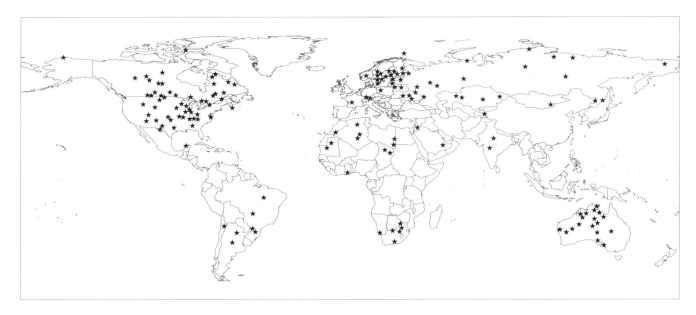

Map of Earth, showing currently known impact structures

Hypervelocity impacts have produced, in the course of minutes, deep scars in the Earth's crust and mantle, some several hundred kilometers wide. But impacts affect not only geological but also biological evolution. To date, we have identified approximately 170 impact structures on Earth of various ages and stages of preservation.

Impact craters occur on Earth in two distinctly different morphological forms.[2] *Simple* craters are small, bowl-shaped depressions with diameters measuring between 2 to 4 kilometers. *Complex* craters are larger in diameter. Craters of both types have an outer rim and are filled with a mixture of fallback ejecta and material, slumped in from the walls and rim during the early phases of crater formation.

Complex craters are characterized by a central uplift, a structure that commonly exposes rocks "uplifted" from a considerable depth and thus providing a contrast to the stratigraphic sequence of the surrounding environs. Usually consisting of dense basement rocks and severely shocked material (described below), this uplift is often more resistant to erosion than the rest of the crater. In old eroded structures, the central uplift may be the only remnant of the crater that can still be identified, as is the case at Gosses Bluff, in Australia.

Remote sensing and geophysical examination are not conclusive in determining the presence of these elusive, ephemeral landforms. Only petrographic and geochemical studies of actual rocks from the potential impact structure provide definitive proof of an impact origin. Various types of breccia and melt rocks provide unambiguous evidence in the form of shocked mineral and rock clasts. During the first phase of an impact event, a shock wave runs into the

[2] The distinction between an impact *crater* (i.e., the feature that results from the impact) and an impact *structure* (i.e., what we observe today, long after formation and modification of the crater) should be made clear. Unless a feature is fairly fresh and unaltered by erosion, it should be called an "impact structure," rather than an "impact crater."

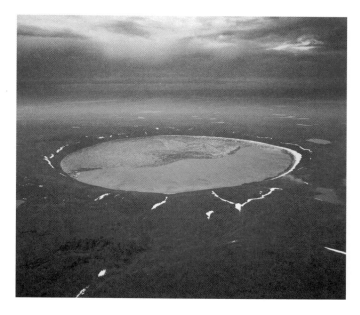 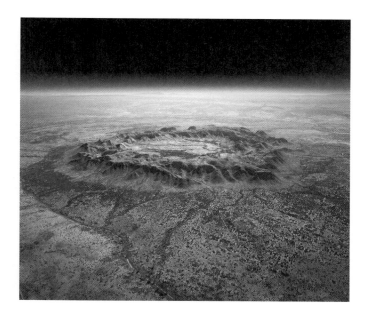

left: New Quebec, an example of a simple crater right: Gosses Bluff, an example of a complex carter

ground, causing irreversible changes to the minerals that make up the various rocks. Shock pressures during impact are a million times greater than atmospheric pressure, and temperatures in excess of 3000°C are produced in large volumes of target rock. These conditions differ significantly from the norm. Volcanic eruptions, for example, create pressures up to only a few thousand times atmospheric pressure, with maximum temperatures of 1200°C. Macroscopic shock features include the so-called shatter cones—strangely striated conical rocks unique to impact structures. Microscopic features range from simple "shocked quartz grains," characterized by Venetian-blind-like lamellae, to high-pressure varieties of common minerals, such as coesite, formed from quartz, and diamond, formed from graphite.

The detection of small amounts of meteoritic matter in breccias and melt rocks can also provide confirming evidence of impact; however, only elements that have high abundances in meteorites but low abundances in terrestrial crustal rocks are useful in this regard. Platinum-group elements and elements that exhibit similar chemical behavior, such as cobalt and nickel, are commonly studied. Elevated siderophile element contents in impact melt rock, as compared to target rock, can indicate the presence of either a chondritic or an iron meteoritic component. At present, however, meteoritic components have been identified for less than one-quarter of the impact structures identified on Earth.

———

Looking back in time, collisions and impact processes have played essential roles throughout the history of our solar system. Small bodies grew through collisions, ultimately forming the planets. Earth evolved this way, more than four-and-a-half billion years ago; it was still growing when a Mars-sized protoplanet collided with it, leading to the formation of the moon. But if these violent collisions were creative forces, they were also powerful forces of destruction.

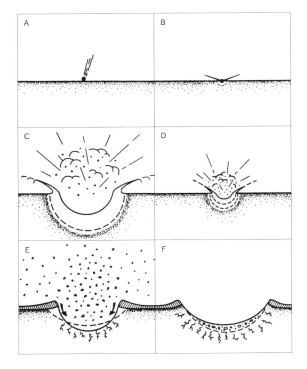

Series of schematic drawings showing the formation of an impact crater

The quantity of energy released during a small impact event, which may cause a crater measuring 5 to 10 kilometres in diameter, is similar to the amount released over several months during the 1980 eruption of Mount St. Helens. The entire annual energy release on Earth from volcanism and earthquakes (including heat flow, which is by far the largest component) is comparable to the energy released during a large impact event. That energy is concentrated in a single point on the Earth's surface, leading to an enormous local energy increase. The collision of a medium-sized asteroid or cometary nucleus would therefore release the same amount of energy within seconds that the whole Earth releases within hundreds or thousands of years.

So if the paradigm of twentieth-century geology shifted to include impact as an external force of geological evolution, it also shifted to include impact as a potent source of biological evolution. The effect of impact events on the global environment and on the biological evolution of our planet has only recently come to light.

Our planet's history is punctuated by mass extinction events. The one that took place sixty-five million years ago, marking the Cretaceous-Tertiary (K-T) boundary, is perhaps the best known. The first physical evidence of an important impact event was the discovery, by Louis and Walter Alvarez and their colleagues in 1980, of anomalously high platinum-group element abundances in the thin layer that marks the transition from Cretaceous to Tertiary rocks. Shocked minerals, microscopic diamonds, and other indicators of a likely impact event were subsequently found. A great debate raged within the geological community, and most earth scientists remained skeptical of the claim that this meteorite impact had led to the extinction of more than 50 percent of living species, including dinosaurs, pegged to this moment

in geological history. Only the discovery in the early 1990s of a mammoth impact structure measuring approximately 200 kilometers in diameter, completely buried under younger rocks of the Yucatan Peninsula in Mexico, cast aside their doubts. Detailed studies show that this crater is of exactly the right age and that all of the chemical and petrographic characteristics of its rocks fit those of the ejecta layers discovered around the world. Chicxulub was indeed the long-sought K-T impact structure.

At present, Chicxulub is the only impact structure for which a relationship to a major mass-extinction event has been established. Nevertheless, it is clear that impact events have been much more important for the geological and biological evolution of Earth than assumed just a few years ago. Even the impact of relatively small asteroids or comets can have disastrous consequences for our civilization, and there is a one-in-ten-thousand chance that a large asteroid or comet, measuring 2 kilometers in diameter, will collide with Earth during the next century, creating a crater measuring 25 to 50 kilometers in diameter, disrupting the ecosphere, and potentially annihilating a large percentage of the world's population.

Impact structures and the processes by which they form should be of interest not only to earth scientists but also to society in general. The study of impact craters is an absolute prerequisite for understanding of some of the most fundamental problems facing our planet today. Research on impact craters continues in the twenty-first century with a vigor that identifies it as an important new topic in the fields of astronomy and the geosciences. It is my hope that this book will help a wider audience become interested in these fascinating geological features.

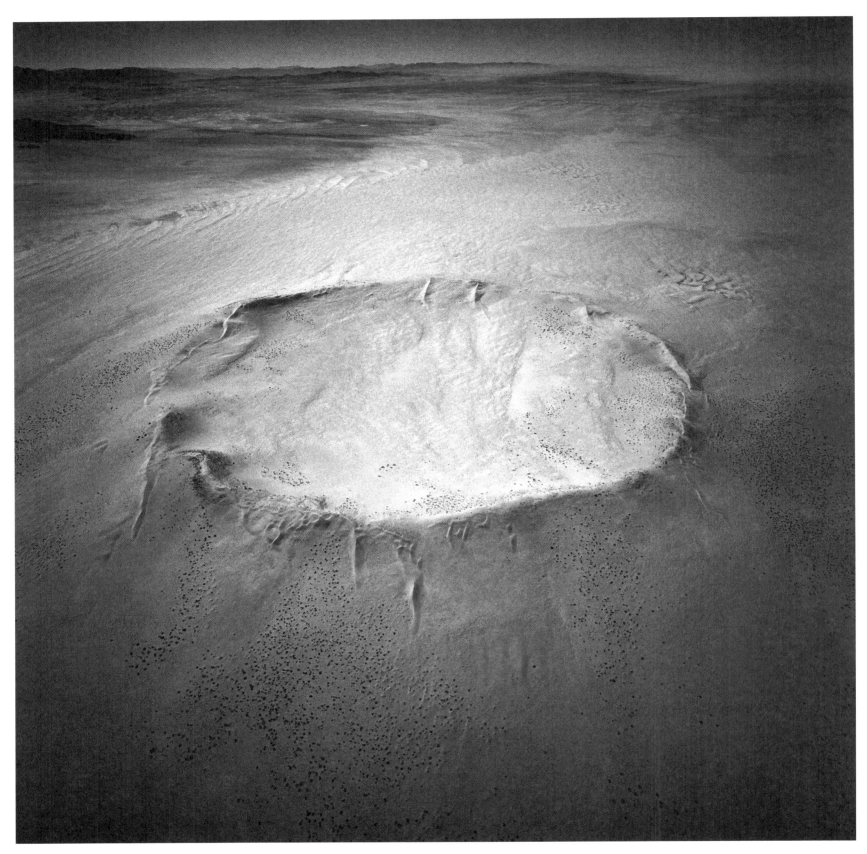

Roter Kamm, Namibia

Between Heaven and Earth:
The Impact Photographs of Stan Gaz

ROBERT SILBERMAN

Among the earliest extant photographs are several by Louis Jacques Mandé Daguerre (1787–1851) that show a Parisian boulevard as viewed from an elevated vantage point. As a matter of convenience, it was presumably easier for this photographic pioneer to shoot from above than to take his equipment down to ground level. But Daguerre's lofty view also gives his photographs an expansive sense of space. The elevated perspective energizes the image and entrances the viewer with a sense of the prospect. In the most famous example, only a single figure is visible: a man apparently having his boots shined. He is standing still while all of the pedestrian and street traffic moving around him fails to register on the plate because of the lengthy exposure time.

Many of the innumerable photographs that followed this notable start represented, in effect, the movement of the camera down to ground level. Some, however, moved in the other direction, as the camera rose to ever greater heights—to taller buildings, to mountaintops, and even more dramatically, to the sky in a hot air balloon, when the photographer Nadar (pseudonym of Gaspard-Félix Tournachon, 1820–1910), famous for his celebrity portraits, ascended above the rooftops of Paris and recorded the city below in an attempt to prove photography capable of serving as an instrument for mapping. Honoré Daumier (1808–1879) satirized Nadar's effort in his famous lithograph of 1862: "Nadar Raising Photography to the Height of Art."

The ascent of photography's vantage point has continued to the present, moving from balloons to airplanes to satellites, manned spacecraft, and finally probes that beam back data from Mars and other distant locations, to be transformed into images. The camera's upward movement culminated in one of the most memorable images of all time—a record of Earth. The iconic "Earthrise" photograph, made by Apollo 8 astronaut William Anders in 1968, demonstrates how a change in perspective can provide a different view of the world, and therefore a different world view.

Views of Earth from above can go beyond matter-of-fact records created for scientific purposes to become images that inspire a sense of wonder. Stan Gaz, in his photographs of meteorite impact sites, creates that kind of amazement and awe. He photographs from above, in aerial views that capture the grandeur and drama of these locales where projectiles from outer space entered our atmosphere and collided with Earth. He also works from ground level, with a perspective that is literally more down-to-earth but displays no feeling of ordinariness, given the exceptional character of the sites.

Meteorites have always been surrounded with an aura of mystery. The scientists interested in astronomy and outer space, together with those interested in geology and the earthly landscape, and countless amateurs, pursue these objects with fierce, almost cultish dedication. Collectors pay enormous prices for exceptional specimens, the geological-astronomical equivalent to truffles. Because the world of meteorites and impact structures combines heavenly

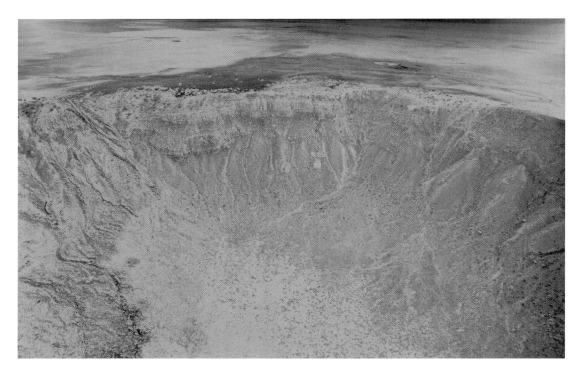

Meteor Crater, Arizona, United States

matters with earthly ones, it also attracts the intense involvement of science fiction buffs and the religious or spiritually-minded.

Not surprisingly, consensus about meteoritical events is frequently elusive. The fundamental questions are ones of causality: What created the impact structure, and how exactly was it formed? The technical analysis of gravitational force and scatter fields; the methodical attempts to analyze rock composition; the earnest attempts to hypothesize a linear sequence of events: all seem outmatched by the visual effects produced by the physical impact and overshadowed by the larger questions they pose. That is no doubt because the finite evidence—the craters and the meteorites, whether the size of gravel or of a huge boulder—points outward, beyond the immediate scene (off-screen, as it were) away from the surface of the earth and toward the infinite reaches of outer space. These sites represent the terrestrial, yet evoke the celestial.

Gaz's photographs bear witness to cataclysm but reveal no agent. As in the ruins and relics of vanished ancient civilizations, a sense of mystery surrounds the sites he visits, an enigmatic quality one might call the "Ozymandias effect"—a presence haunted by an absence. Ancient ruins stimulate meditations on the greatness of civilizations that built so monumentally, and on the decline and fall that led to their abandonment and decay. The impact sites offer a physical record marking both creation and a kind of self-destruction, for although meteorites are sometimes discovered, more often the asteroid is destroyed on impact, leaving behind an enormous hole. Gaz's images reveal the product of an overwhelming, instantaneous event, shaped by astrophysics and physics, yet with historical and even metaphysical implications.

There is something unworldly about the sites, with their great circles or scatter-shot patterns inscribed in the landscape. Even when some ground cover is present, such places seem more akin to the lunar landscape or the surfaces (actual or imagined) of other heavenly bodies: rough physical matter, exposed to the elements, devoid of all signs of human activity. The forms are visible, in some cases for miles, but the sites offer immense interior spaces as well. The interiors have an unusual psychological power: although the product of destruction, they seem oddly sheltering and protective. Viewed from the ground, the craters resist complete comprehension; there is still the distance to the far side of the crater, to the outer reaches of vision. The best-preserved impact structures, with their pronounced rims, steep walls, and clearly defined central uplifts, are exceptional topographic features that in their strangeness hold our attention as unnatural natural wonders.

———

Stan Gaz became caught up with meteorite impact sites when he was seeking a new subject for his art after an intense period creating a series of works devoted to the World Trade Center disaster. Those drawings and sculptures incorporated ash, rubbed into the surface of works on paper and enclosed within the glass or metal of three-dimensional creations: the pieces are, in effect, modern reliquaries. In an effort to do something completely different, and to free himself from the darkness of 9/11—Gaz lived in downtown Manhattan, close to the Twin Towers, and was at home that day—he turned to an earlier love, geology.

Gaz's father was a geologist, and among the artist's earliest memories are expeditions with his father throughout the West, gathering rock samples. The son recalls with pride those moments when his own collecting efforts met with the approval of his father, an at times difficult man whose role in the boy's life ended at an early age, following divorce. The meteorite project therefore represents an escape from one difficult psychological situation and a return to another, though with a kind of reconciliation and resolution. Around the time Gaz began to work on the project, he found a meteorite from his childhood rock collection, given to him by his father, which had always fascinated him, "maybe because it came from another world."[1]

What at first presented itself as a casual side trip during a visit to the Southwest turned into a consuming passion. As Gaz puts it, he was "hooked." It all started when he was in Flagstaff, Arizona, and hired a pilot to fly him over nearby Meteor Crater. He thought it would be an entertaining diversion, maybe even an adventurous excursion, but not the beginning of an artistic preoccupation played out as a globetrotting odyssey. Although as an art student he had "no interest in landscapes whatsoever," the impact sites immediately appealed to him because they bring together science and religion, the known and the unknown, and make people think not only about the past and the present but about the future—the fate of the planet.

Of the meteorite impact structures that Gaz set out to photograph, only three major sites eluded him: one in Brazil, one in Africa, and one in Russia. After conducting preliminary research, the first two seemed to carry adventure-seeking too far beyond the bounds of even extreme tourism. The journey to Tenoumer Crater in Africa, for example, would have

[1] All quotations of Stan Gaz are taken from an interview with the author, New York City, January 11, 2008.

required a trip by superlight aircraft over unpopulated desert, with no obvious backup plan and little possibility of rescue in case of an accident. The cost of a ground expedition bordered on extortion. In the case of Russia, the danger of traveling to the site, given the unsettled state of post-Soviet society, was equally unnerving. As it was, Gaz admits, he had experienced just about enough aerial adventure: "I couldn't wait to stop taking helicopter rides." His first experience, with a daredevil Vietnam vet pilot who seemed to want to play chicken with his client, rather than serve the needs of his photographic mission, set the tone for a series of experiences of borderline flying made more nerve-wracking by the need to somehow capture the views out the aircraft window or door without dropping the camera or falling out.

Those experiences are not evident in the photographs, with their formal control: product trumped process. Black-and-white images, they avoid the more picturesque possibilities. They cultivate not so much a neutral, scientific objectivity as an aesthetic, expressive power, through which they enter the realm of the sublime—that combination of majesty, awe, and more than a little intimidation. In an age of color imagery, the use of black and white has an abstracting effect, even as it lends a sense of seriousness to the enterprise and the images. The large prints, created by the photographer in tandem with master printer Charles Griffin (who also works with Hiroshi Sugimoto), are magnificent: they exploit tonal range and intensity to do justice to the scale and grandeur of their subjects. As Gaz progressed, he learned how to frame the craters within the image as something more than a matter of centering under difficult conditions. Sometimes aided by good fortune in temporary weather conditions, he managed to capture the power of nature visible in the sky and, especially, on the horizon.

The formal beauty and power of the images heightens the beauty and power of the subjects. Located in relatively barren landscapes, free of forests or other obscuring vegetation, the empty, isolated sites have some of the "vast and heartless grandeur" artist Rockwell Kent found in the Arctic, and the "magnificent desolation" astronaut Buzz Aldrin found on the moon.[2] There are few signs of civilization in Gaz's photographs. The shadows of the aircraft, an acknowledgement of the photographer's presence, recalls the famous image by American photographer Timothy O'Sullivan (ca. 1840–1882) of his wagon and its tracks in the sand in Nevada, where he worked as part of the Clarence King expedition. The viewing station at Meteor Crater is reminiscent of that once witty, now clichéd, subgenre of images showing tourists experiencing and photographing "nature," but here, he merely documente one human encroachment upon a largely inhuman, uninhabited landscape.

Critics of photography, in trying to distinguish their medium from painting, drawing, and other forms of printmaking, and in particular to explain its special relationship to reality, have adopted the language of deconstructionist theory (notably, that of French philosopher Jacques Derrida) to emphasize the photograph as presenting a "trace."[3] Light traveling from subject to photographic film (or now, digital sensor) leaves a record, creating an image that

2 Kent, quoted in Eleanor Jones Harvey, "The Artistic Conquest of the Far North," 11; Aldrin, quoted in Christopher Phillips, "'Magnificent Desolation': The Moon Photographed," 148; both from the catalog *Cosmos: From Romanticism to Avant-Garde*, ed. Jean Clair (Montreal: Museum of Fine Arts, 1999).

3 See Derrida's *Of Grammatology*, trans. Gayatri Chakravorty Spivak (Baltimore and London: Johns Hopkins University Press, 1976); and *Writing and Difference*, trans. Alan Bass (London and New York: Routledge, 1978).

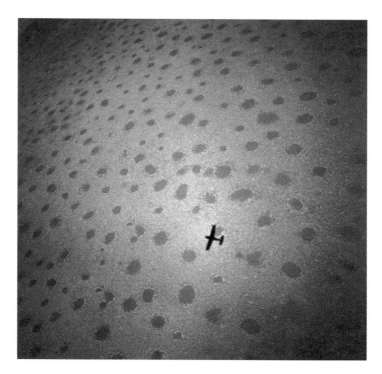

Fairy Circles, Namibia
following pages: Meteor Crater, Arizona, United States

graphic film (or now, digital sensor) leaves a record, creating an image that shows something once present but now absent. For Gaz, who has poetically described the impact structures as "footprints of the stars," photography is "like a reliquary." Photographs provide a visual encapsulation of a treasure, a sight forever captured in an image. In the impact photographs, the landscape itself records an event, and the photograph (in effect using traces of traces) provides an image of the results of the initial occurrence—the apparent first cause. But the records on Earth only mark the end result of a larger causal chain, with the surface of the planet suggesting the final flaming descent, the long journey through space, the unknown origin light years away. The sites of impact, and Gaz's photographs of them, imply a history beyond human history, extending beyond the human vision recorded in the photographs and almost beyond human understanding.

In Gaz's complex representation of overwhelming effects and invisible causes, of the play between earthbound sites and celestial origins, it is appropriate that one of the last images of this book should be an apparent image of the heavens. In what seens at first glance a view of the Milky Way, infinite points of light mark possible sources of the meteors. In fact, the photograph represents the microcosm, not the macrocosm: the blown-up cross section of a meteorite. It is worth noting that one of the preeminent American photographers Minor White (1908–1976) loved to make images that could be read as either extreme long shots of landscapes or extreme close-up views, where scale was difficult if not impossible to determine, as in his pictures of the patterns on a rock face, or ice on a window pane. There is a similar pleasure in the surprised recognition of what the Gaz image reveals, a delight in this ambiguous union of the colossal, even

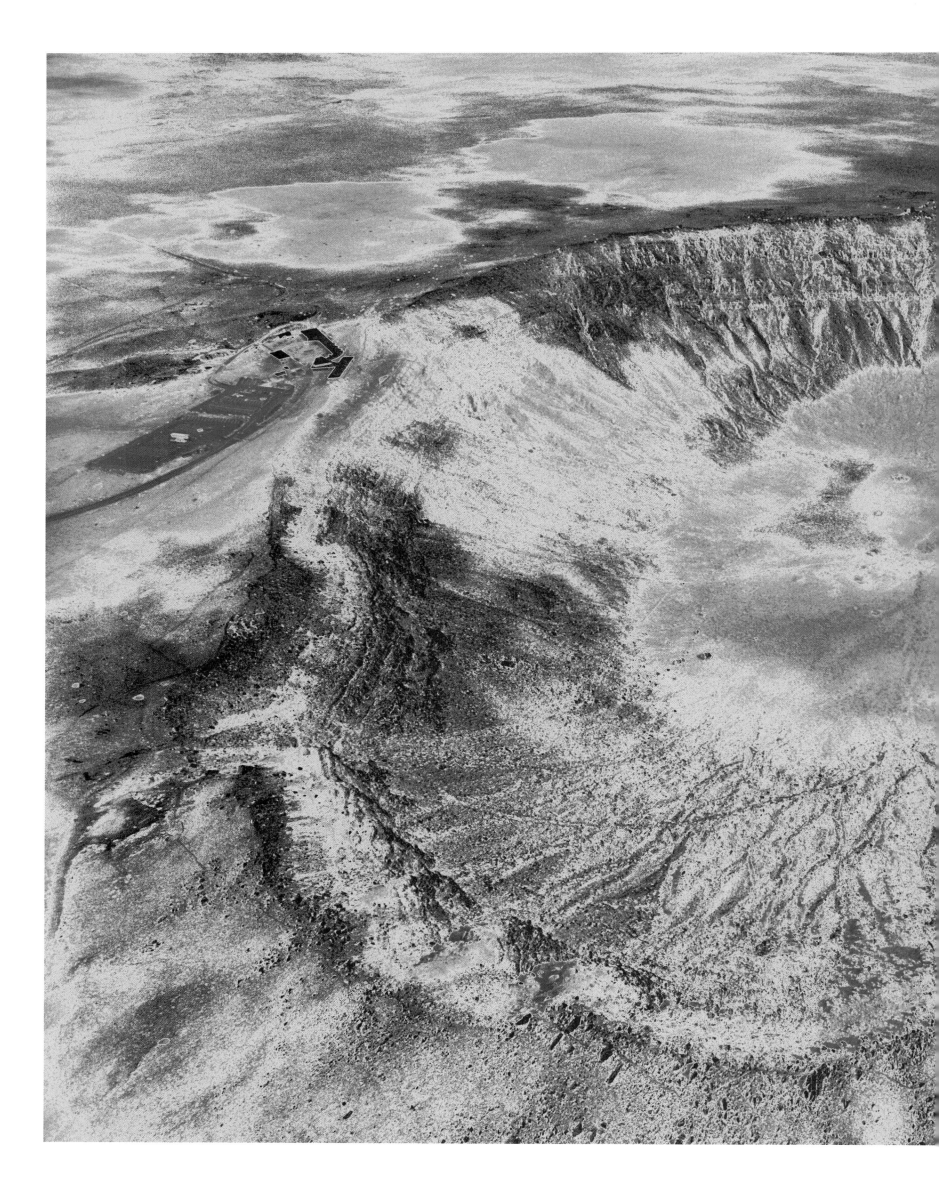

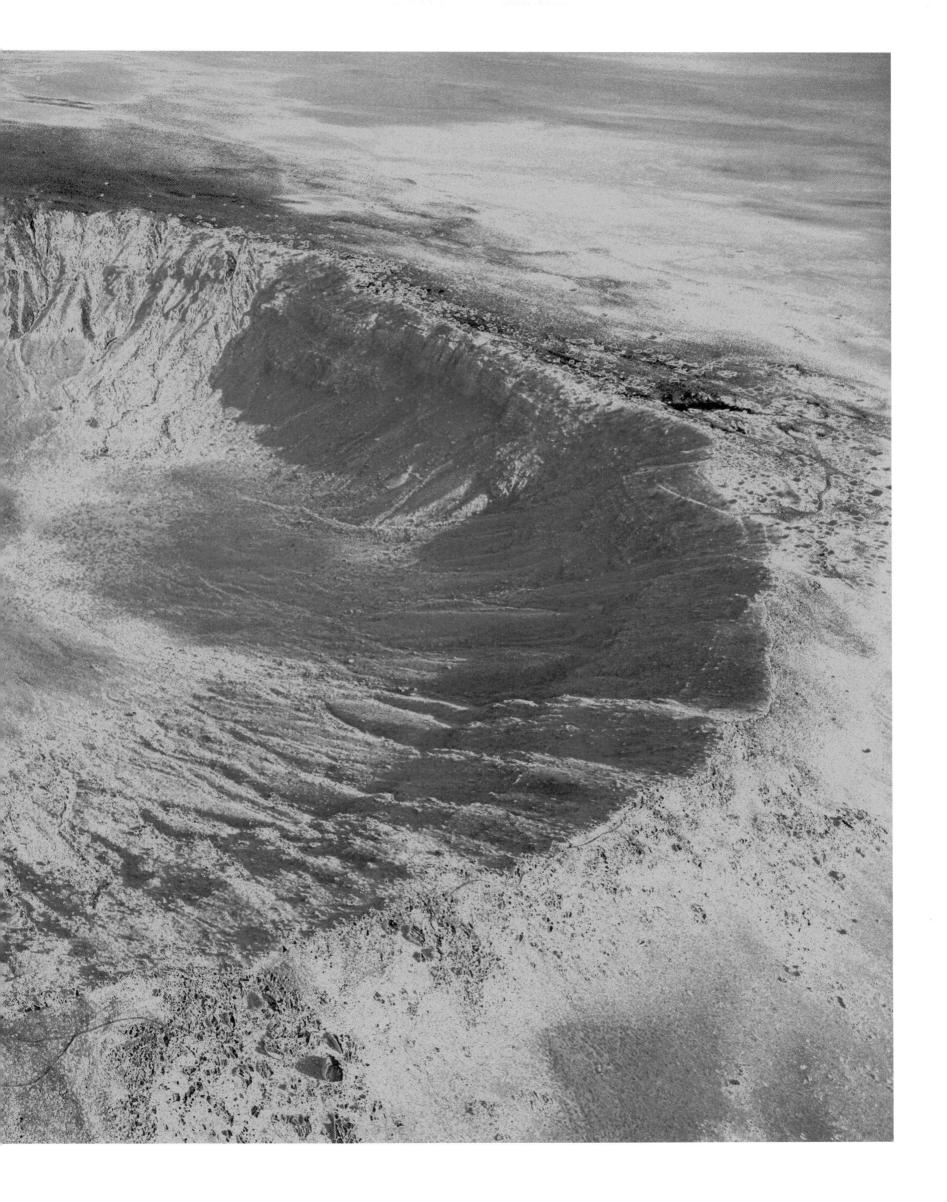

a grain of sand," Gaz's image of a meteorite slice (aptly titled "Toast") is a fitting conclusion to the exploration of the infinite worlds expanding outward from the meteorite impact crater.

The outside surfaces of meteorites (once collected by Gaz's father, now recast by the son in his sculptures, in metals that mirror the minerologic components of the originals) may appear somewhat ordinary—pitted, due to the rusting of their iron particles, or with a molten appearance caused by the heat of entry. By contrast, the insides offer extraordinary crystalline structures. Their intrinsic geometric patterning possesses the "beauty of another order"[4] that natural objects often display—not the product of art, yet exhibiting the qualities associated with artistic creation. Like the aerial views of William Garnett (1916–2006), a great master of aerial photography, there is something to the images of such elaborate forms in nature.

———

In spite of this book's final images, Gaz's photographs are images of the Earth, not outer space. Most are landscapes, not "skyscapes." Notwithstanding their particular subject and their frequent use of an aerial perspective, that is fitting, because for all their singular qualities they can be considered in relation to landscape painting and photography, and in particular, the aesthetic of the sublime (a term that, appropriately enough, means "elevated"). During the nineteenth century in Europe, the great seascapes of J. M. W. Turner (1775–1857), with their spectacular shipwrecks, battles, and storms, and the transcendent mountain scenes of Caspar David Friedrich (1774–1840) perhaps best epitomized a Romantic vision of the sublime. In America the epic images of Niagara Falls, icebergs, and volcanoes by William Frederic Church (1826–1900), along with the five-painting cycle *The Course of Empire* by Thomas Cole (1801–1848), also presented awe-inspiring visions.

But it is the great views of the American West painted by artists such as Thomas Moran (1837–1926) and Albert Bierstadt (1830–1902), along with the photographic images of the West made initially as part of the surveying and mapping expeditions of John Wesley Powell and Clarence King, that serve as the most direct precursor to Gaz's pictures. Whether or not they were influenced by King's apocalyptic view of the landscape and geological upheaval, the photographs of Timothy O'Sullivan depict a world harsh and impersonal. Although an admirer of O'Sullivan, Ansel Adams (1902–1984), arguably the most important figure in American landscape photography in the twentieth century, sometimes portrayed a less intimidating landscape, such as an aspen grove glowing in the light. He nevertheless took pictures on a grand scale and with a sense of the sublime, for instance of a clearing winter storm in Yosemite.

American photographers after Adams also have been drawn to the grandeur of the landscape, but their work has been more overtly shaped by contemporary concerns and, as is the case with Gaz, often emphasize destruction. Frank Gohlke (b. 1942) and Emmett Gowin (b. 1941) independently created images of the devastation occasioned by Mount St. Helens's 1980 eruption. Gowin's later aerials of the Hanford Nuclear Reservation and other nuclear sites in the West, like Gohlke's initial forays at Mount St. Helens, are fraught with overtones of

[4] Ann Thomas, et al., *Beauty of Another Order: Photography in Science* (New Haven and London: Yale University Press, in association with the National Gallery of Canada, Ottawa, 1997).

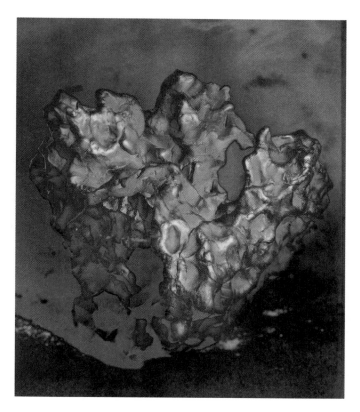

Photograph of Meteorite sculpture by Gaz

nuclear danger and environmental degradation, if not disaster. In particular, Gowin exploits toning to create a strangely beautiful patina that hints at radioactive-chemical toxicity and transformation.

There are, of course, many other photographers at work in related directions, most notably perhaps Marilyn Bridges (b. 1948), whose aerial views of sacred landscapes include Stonehenge (also photographed by Gaz), the Nazca Lines in Peru, and other sites. In spite of his interest in the spiritual and symbolic implications of the circular form and his deeply personal biographical connection to his subject, Gaz's impact crater photographs are more concerned with nature than with culture, more with astronomy and especially geology than with anthropology.

Gaz's images are poised between detachment and engagement, moving as they do between a superior view, from the air, and what we might call a grounded view, from the earth's surface. Perhaps these dual perspectives reflect a duality in the subject matter, for the impact craters both conjure up a fascinating mystery and indicate a frightening cataclysm—a destructive event in the past that necessarily evokes more contemporary disasters, natural and man-made. Aerial views enforce detachment and distance, even as they open up a greater field of vision and create new objects of psychological attraction. For the first philosopher of the sublime, Edmund Burke, terror is the key quality. Perhaps closer in feeling to Gaz's portrayal of earthly wonders was Arthur Schopenhauer's notion that the fullest feeling of the sublime is reserved for an experience of the immensity of the universe's extent or duration.

As the art historian Barbara Novak has pointed out, the awe accompanying nineteenth-century painted visions of epic landscapes is accompanied by intimations of the infinite and thus of "Deity and the divine," leaving the viewer caught between a sense of transcendence and an awareness of insignificance.[5] In a more secular age, that sense of awe concerning the world often finds its aesthetic home in science fiction (a distinctly modern genre) and in the movies (a modern medium). Consider *2001* (1968, directed by Stanley Kubrick), which is also, with its *Thus Spake Zarathustra* score, a reminder of the fine line in this aesthetic realm between grandeur and grandiosity, beauty and bombast. In her classic essay "The Imagination of Disaster," Susan Sontag observed that science fiction movies went beyond science fiction literature in their "immediate representation of the extraordinary."[6] A similarly compelling representation of the extraordinary is at the heart of Gaz's photographs.

In *Rebel Without a Cause* (1955, directed by Nicholas Ray)—no science fiction film but a movie shadowed by some of the same social and psychological forces as the science fiction films of the time—Jim Stark (James Dean) goes on a field trip with the students from his high school to the Griffith Park Observatory in Los Angeles. In the planetarium the students attend a lecture-demonstration. When Jim enters, the lecturer's first phrase concerns the "immensity of our universe." The talk immediately goes on to describe "the end of our Earth" being preceded by "a star...increasingly bright and increasingly near" that will bring on "changes in weather, the division of the polar ice fields, warmer seas," dramatic changes set against a background of the heavens "eternal, unchanged and little moved by the shortness of time between our planet's birth and its demise." Accompanied by appropriately dramatic visuals, the speaker concludes with a flourish:

> And while the flash of our beginning...
> has not yet traveled the light years into distance...
> has not yet been seen by planets deep within the other galaxies...
> we will disappear into the blackness of the space from which we came...
> destroyed as we began, in a burst of gas and fire.
> [Explosion]
> The heavens are still and cold once more.
> In all the immensity of our universe and the galaxies beyond...
> the Earth will not be missed.
> Through the infinite reaches of space...
> the problems of man seem trivial and naive indeed.
> And man, existing alone...
> seems himself an episode of little consequence."

[5] Barbara Novak, *Nature and Culture: American Landscape and Painting,* 1825–1875, rev. ed. (Oxford University Press: New York and Oxford, 1995), 34.

[6] Susan Sontag, "The Imagination of Disaster," in *Against Interpretation, and Other Essays* (New York: Noonday Press, 1966), 212.

As the other students file out, Jim says to Plato (Sal Mineo), who was unnerved by the spectacle, "Hey. Hey. It's all over. The world ended." Plato replies, "What does he know about man alone?"

The scene presents an existential isolation heightened by a sense of an indifferent but potentially destructive universe: a modern view of the world. In recent decades, science fiction has registered, sometimes awkwardly, a renewed interest in outer space and the threats it posed (aliens, in films such as *Independence Day* [1996, directed by Roland Emmerich]; "an asteroid the size of Texas," in *Armageddon* [1998, directed by Michael Bay]), if only to play up heroic human responses. It is hard not to see such disaster films as expressions of real fears with fantasy resolutions. The meteorite shower that bombards New York in *Armageddon* resembles a military attack but avoids any human causality, including the usual demonic villains. In the post-9/11 age, a television mini-series such as *10.5 Apocalypse* (2006, directed by John Lafia) uses spectacle and special effects to obliterate any sense of reality. Yet like the films, it still manages to summon up in its unreal narrative, if only by indirection, a sense of the genuine anxiety lurking behind its artificial hysteria and unconvincing heroics.

One turns from such action-adventure spectacles to Gaz's images with relief and gratitude. Even in less-calculating cinematic spectacles such as standard Imax flyover footage, the medium becomes the message. In an age of such dynamic but often hollow presentations, and with Google Earth making possible endless zooming in and zooming out, Gaz's images provide a reminder of the power of the still image, the still view. His photographs offer the concentration, and contemplation, made possible by non-motion pictures. The aerials may have been made while Gaz and his camera were moving with great speed, but the results suggest the suspension of time and motion. Their stillness frees us from the rush of experience and opens up the possibility of calm consideration of the wonders Gaz reveals.

The meteorite impact images are at once somber and exhilarating. They document massive destruction and therefore remind us of human vulnerability, of how quickly and completely lives can be changed, with no warning. Yet as images they have their own power, and establish a new, elevated point of view that carries both risks and rewards in the form of revelations. The images may seem almost timeless—an escape from history—and yet they are obviously of the moment, shadowed by 9/11 even as they carry us as far from Ground Zero as possible. The images provide evidence of historical cataclysm and therefore can serve as contemporary images of apocalypse. Like the planetarium presentation in *Rebel*, they seem appropriate for our times. Yet they are precisely balanced, not only between earth and heaven, looking toward one while invoking the other, but also between fear and wonder, a sense of disturbance and a sense of beauty, all established by Gaz's great skill in "the immediate representation of the extraordinary."

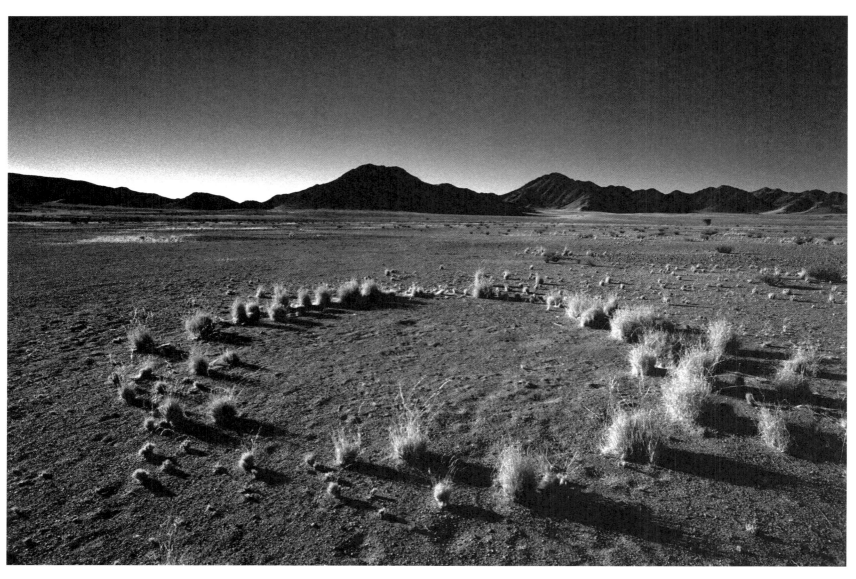

Fairy Circles, Namibia

Field Notes

STAN GAZ

Any parent can tell you, young children ask questions and expect their parents to have all the answers, ready at a moment's notice. When I became a father, I wasn't quite prepared for the types of questions my children would present to me.

One afternoon when my daughter, Kai, was nearly four years old, she asked me, "Can we fly?" My son, Keenan, now three, recently asked, "Who lives on the moon?" In an odd way, these questions were not so different from the ones I asked myself before I started the series of photographs presented in this book. I have often contemplated what lies within our capabilities, and what lies beyond our world.

My own father, a licensed geologist, inspired my deep interest in the Earth and all that surrounds it. Some of my fondest memories are of our rock-hunting expeditions near our home in Joshua Tree, and in the Mohave Desert. I carried the canteen, and he carried the heavier tools. Sometimes we found things that were beautiful and astonishing; other times, we found nothing. As we continued our journey as father and son, our conversations were sometimes full; other times, just a few words were spoken. I would often ask my father questions similar to those my children ask me now.

I inherited my father's passion for geology, for the desert landscape, and for rocks. Like him, I am absorbed in a constant search for nature's treasures. What led me to this photography project was a meteorite. When I first saw this rock, which had been hurled at Earth from outer space, I became captivated by it. Shortly afterward, I decided to take a trip to Meteor Crater, in Arizona. When I got there, I could not believe that it was real. Formed by an enormous meteorite that was traveling so fast that when it hit the earth it created an explosion equivalent to twenty atom bombs and displaced eleven million tons of dirt, the space was massive. It had an emotional effect on me that was overwhelming. Standing on the edge of this crater was like standing inside a cathedral. I picked up some sand in my hand, and for the first time could feel the shape of the earth. I knew right away that I wanted to photograph it.

After taking pictures from the ground, I decided to rent a helicopter and take more pictures from the air. This marked my first time flying at high altitude with the doors off the plane. Hovering above the crater at 3,000 feet, with only a Volkswagen seat belt around my waist, I can honestly say I felt uneasy. As the pilot tipped the machine onto its side, he assured me that gravity and velocity would keep me from falling out, but it took me a while to trust what he was saying. When I got used to the strange feeling of being suspended above the landscape, I was able to focus on getting interesting angles for the pictures. It became exhilarating. I felt like a tripod with wings, or Mercury with a camera.

The photographs I took during the series of expeditions that followed are of meteorite impact structures and their surrounding landscapes. To get to where many of the craters are located, I traveled through isolated areas, far removed from man and man's development. The main reason why these craters have survived, rather than having been plowed over or built

Squall over Beaverhead Crater, Montana/Idaho, United States

upon, is that they tend to exist in areas with harsh or less-than-desirable living conditions, like the desert and the Arctic tundra. Having grown up in a small desert town, I felt an immediate connection to these desolate regions. The landscape felt familiar. With its unencumbered view of the night sky, the desert is a place that feels closer to the stars, and the rocks there seem like they have been thrown by the hand of God.

These trips became quiet pilgrimages to remember and respect the footprints of the stars. They took me all over the world. I spoke with people in parts of Australia, Africa, the Arctic Circle, and the western United States, and many shared the stories and beliefs that have been attributed to the impact sites throughout history. Although each culture's tale was different, all considered the craters to be sacred. These are places that ancient peoples and tribal communities were convinced held answers to the secrets of life—of where the world came from, and of what caused us to be.

In Australia, Aboriginal tribes believe the impact structures were created by gods and goddesses. According to the Aboriginal Dreamtime, every meaningful activity, event, or life process that occurs at a particular place leaves behind a vibrational residue in the earth, just as plants leave an image of themselves behind as seeds. The shape of the land—its mountains, rocks, riverbeds, and waterholes—and its unseen vibrations echo the events that brought the place into creation. Everything in the natural world is a symbolic footprint of the metaphysical beings whose actions created our world. As with a seed, the potency of an earthly location is wedded to the memory of its origin.

The Western Arrente Aboriginal peoples believe that the Tnorala crater in Australia's Northern Territory, or Gosses Bluff, as it is referred to by the scientific community, was formed in the time of creation, when a group of goddesses danced across the sky as the Milky Way. During this dance, one of them put her baby to rest in a "tuma," or wooden bay carrier. With

the dancing, the tuma rocked and accidentally toppled over the edge of the dancing area. It was sent crashing to the earth, where it formed the circular rock walls of the Tnorala crater.

In Western Australia, there is a crater known to the local Djaru tribe as Kandimalal, also known as the Wolfe Creek crater. Local tribesmen believe that a rainbow serpent emerged from the earth where the crater is located and then carved sinuous paths across the desert, forming Sturt and Wolfe creeks. It also formed an underground tunnel linking the crater to the tribe's ancestral homeland. The tracks of the rainbow serpent opened the way for the first ancestors—the Dingo and the Old Man.

In North America, some Native Americans believe that meteorites possess special healing powers. Clackamas tribal legend tells of a giant rock called Tomonowos, variously translated as "heavenly visitor" or "visitor from the moon," that dropped from the sky in a time beyond memory. At night during certain seasons, the tribe held the spiritual initiation of young men alongside the fifteen-ton iron and nickel meteorite. Believing that the rainwater that filled the rock's depressions was holy and imbued with special powers, they ritualistically washed their faces with it and dip their arrows into it. After being displaced from their lands in what is now northwest Oregon by the treaty of 1855, tribesmen continued to make pilgrimages back to the Willamette Valley to visit the sacred rock.

———

On my own pilgrimage, the initiation rites were less spiritual. There were all the logistics of renting a plane to fly over the impact sites, and then actually photographing the crater from an open window or side of a plane. Sometimes the wind was so strong it felt like it would pull the camera out of my hands. Sometimes just getting to the impact site was a challenge. After taking a commercial flight to Canada, I switched to a smaller plane, and then a smaller plane, and then another plane—five flights in all—to reach a remote Inuit town in the Arctic Circle. I flew over the Beaverhead crater, which straddles Montana and Idaho, in the smallest helicopter I had ever been in, and on the way we flew straight into a storm. It was like flying in an ocean. At Wolfe Creek, the plane looked like something from a garage sale, as if the pilot had glued it together and spray-painted it black. Whenever I felt uncomfortable about flying, my first question to the pilot was always, "Where did you learn to fly?" When I asked this pilot, he said he "just picked it up." "Not to worry, though," he had been flying "for a couple of months."

More experienced pilots didn't always provide greater reassurance. At Meteor Crater a Vietnam vet took me up. His plane looked like it had flown in that conflict, too, with Coke-bottle glass covering the controls, some of it broken, so I was nervous from the start. After reaching the clouds, I looked down and felt even more uneasy. The pointy rocks of a canyon went on as far as the eye could see. Then the engine seemed to sputter out. I looked at the pilot, and his eyes were closed. He was hunched over, like he was sleeping, or had had a heart attack. I yelled, "This thing is going to crash!" and he came to. He was able to get the engine working again, but I had had enough flying for a while.

Sometimes the dangers were not so much physical as political. Roter Kamm is located in Namibia, in the middle of a restricted diamond area. The mines are heavily guarded, and even the air space above them is tightly controlled. When I photographed the crater, we had to stay

above 10,000 feet. I could barely breathe up there. The doors were off the cockpit, and the cold air was freezing my fingers off. After I finished taking pictures, I realized that we were in and out and above the clouds. The thought crossed my mind that maybe I could touch one, or feel it as it passed through me. The white, fluffy transparency of the clouds made me feel like I was someplace special, like I was caught in a dream, somewhere between heaven and earth.

Back on the ground, I decided to photograph in the Namib Desert, which surrounds the crater. It is considered the oldest desert in the world, having endured arid or semi-arid conditions for at least 80 million years. Its sand dunes, which rise up to 340 meters, are among the tallest in the world. The complexity and regularity of the dune patterns have been studied by geologists for decades but still, no one really understands how they are formed. Walking through the sand, seeing nothing but dunes, the wind blowing my footprints away: it was awe-inspiring.

If I could arrange access, I would walk instead of fly, or do both. Being inside the crater was sometimes a transporting experience. I arrived at Gosses Bluff after a six-hour drive, the last four of it on unpaved roads. The central uplift (the only part left of the original impact structure) looked like a numinous mountain emerging from the landscape. The sun had just started to rise, and a golden light made it glow as if it were on fire. I was on the roof of my truck with the tripod and camera, taking pictures as quickly as I could before the beautiful light disappeared.

At the Henbury crater field, the flat, rocky landscape made me feel like I was on a different planet. Walking around the impact site, I couldn't help imagining what it would have been like to be present at the moment when the asteroids hit—when the fiery angels came screaming out of the sky, exploding into fire and sending out a bright flash of light, carving out a gaping hole in the ground and causing mountains to form, making the surrounding life disappear into ash.

Juxtaposed against the memory of the physical violence that had once assaulted these places was an incredible sense of calm. Alone on the ground, I was struck by their quietness. From the air, I was drawn to the simplicity of their forms—a perfect circle, inscribing Mother Earth. Flying over Tswaing, in South Africa, I kept thinking, if there were a bird so big that it could fly down from the stars and make a home on this planet, this is where it would choose to live; a place this remote and quiet, a place as serene as this.

———

These sites of impact are places caught between our dreams and reality. They are footprints of the stars, left in the sand for us to explore. They represent simultaneous destruction and creation, death and life, past and future. They are the circle of life, writ large; physically, environmentally, and metaphorically.

The images I photographed have persisted in my memory, just as the events that created them have persisted in the memory of the environment and the peoples that lived around them. For me, these photographs of the landscape, connected as they are to another place outside of our world and beyond the our daily experiences, explore our planet's tenuous place in the universe. They underscore the permanence and fragility of our world, and pay homage to the ephemeral composition in which, and with which, we live.

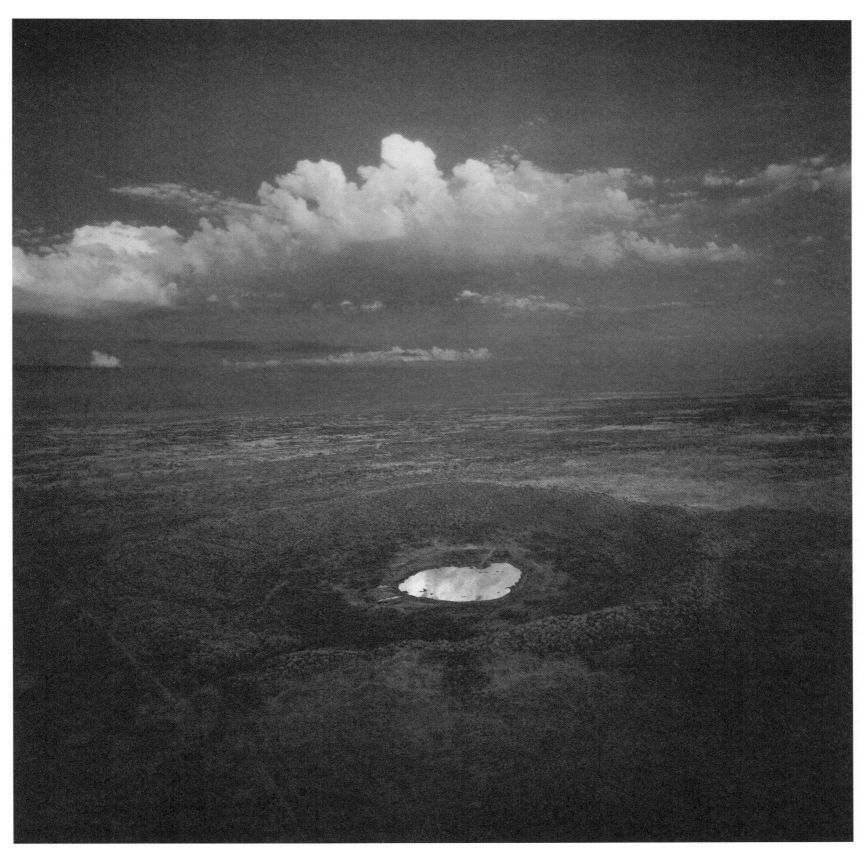

Tswaing crater, South Africa

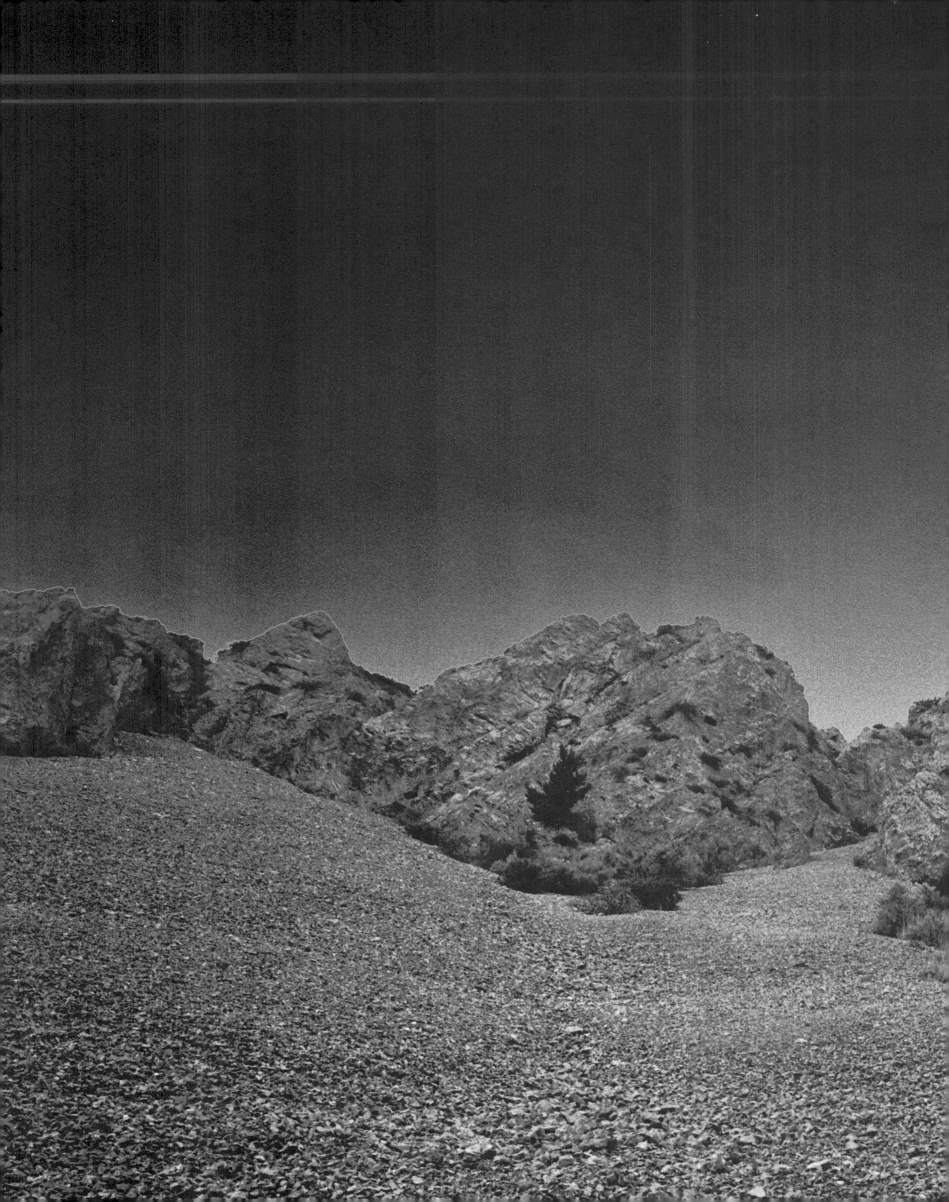

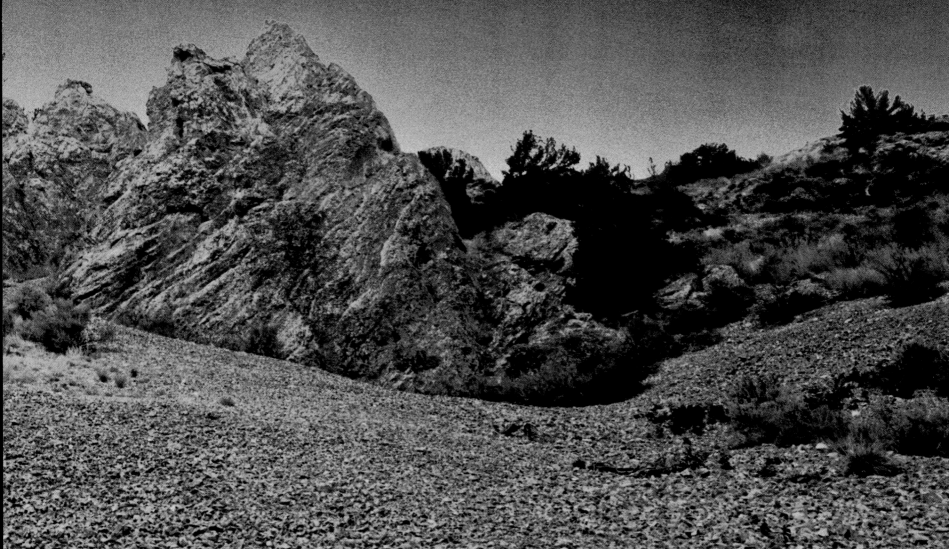

SITES OF IMPACT

BEAVERHEAD

44°36'N, 113°00'W

Location: MONTANA／IDAHO, UNITED STATES

Diameter: 75 KILOMETERS (ORIGINAL DIAMETER)

Crater type: COMPLEX CRATER

Age: >900 MILLION YEARS

Geological condition: DEEPLY ERODED

Impact evidence: SHATTER CONES, SHOCKED MINERALS

Meteorite type: UNKNOWN

The casual visitor could be forgiven for not noticing that there is an impact structure in south-western Montana, possibly crossing over into Idaho. Hundreds of millions of years of erosion have taken their toll, and no crater form or shape remains. The existence of an impact structure was inferred from the presence of shatter cones, and the original crater dimensions were reconstructed based on the isolated occurrences of breccia patches.

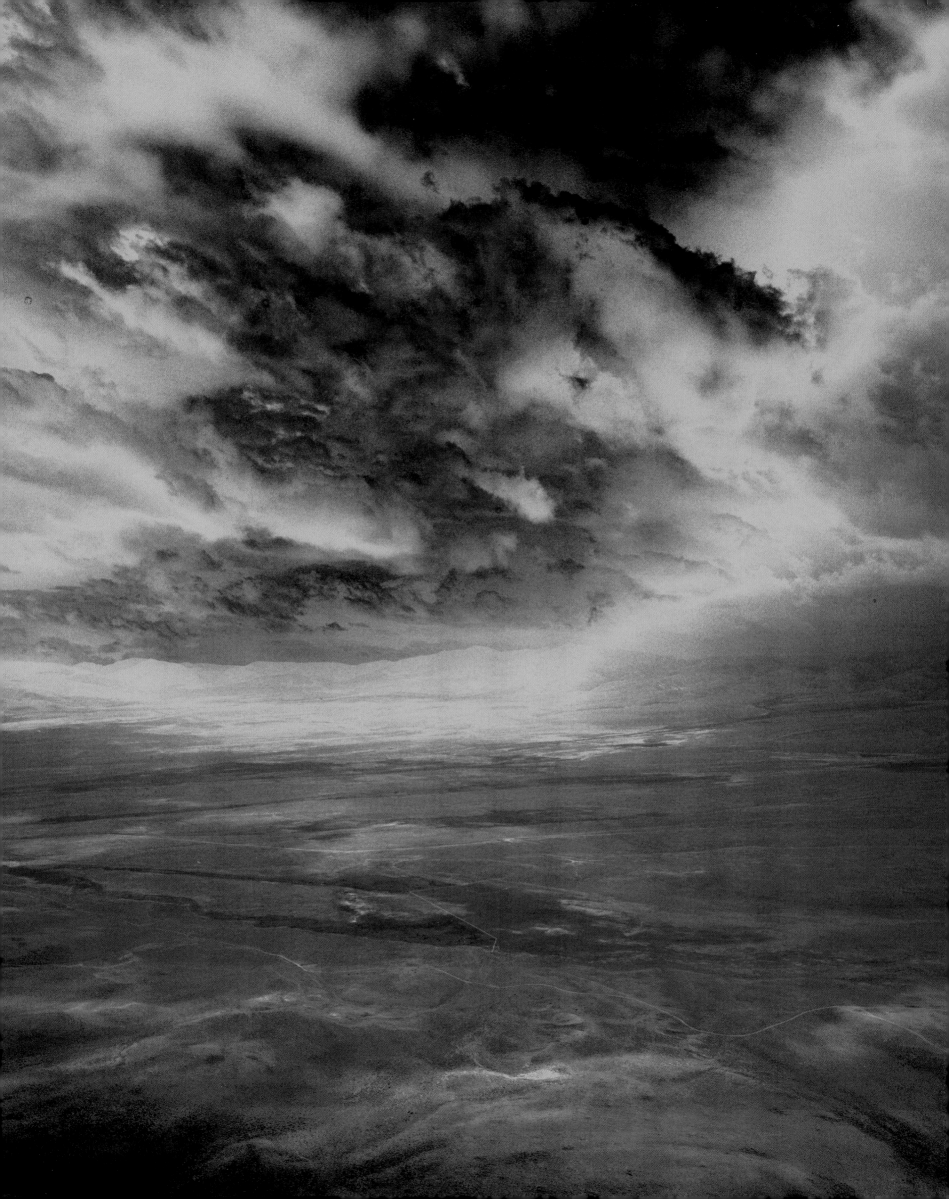

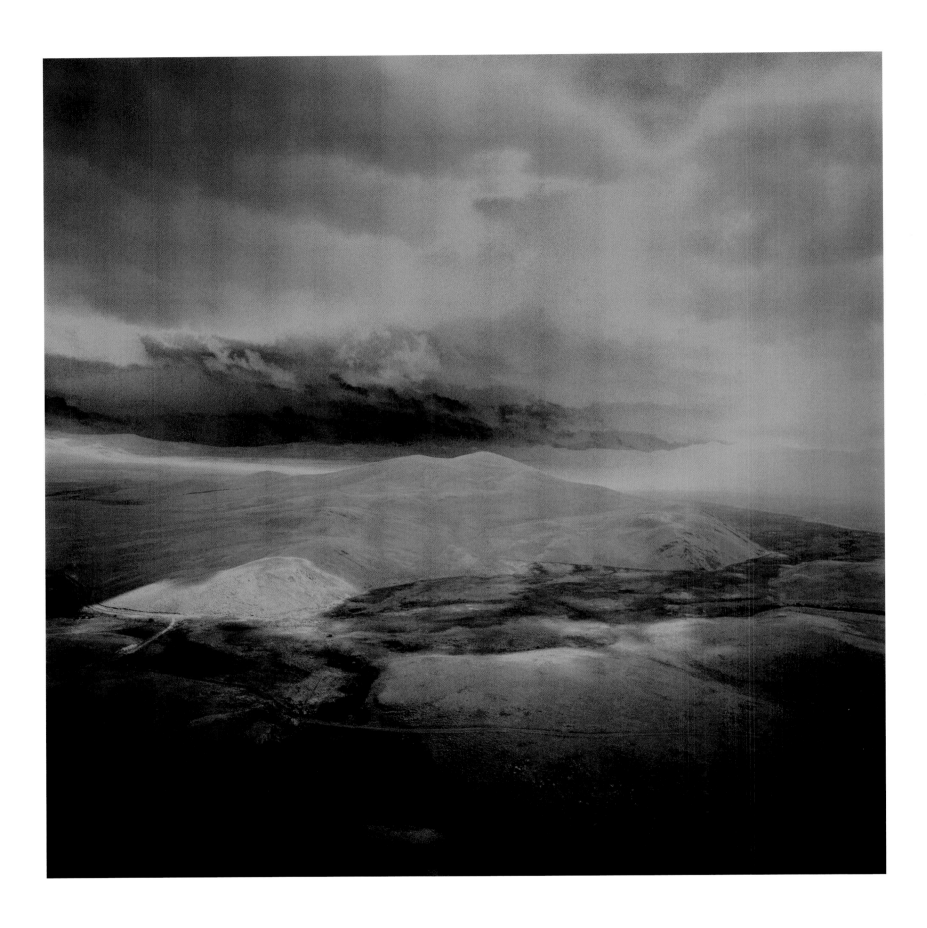

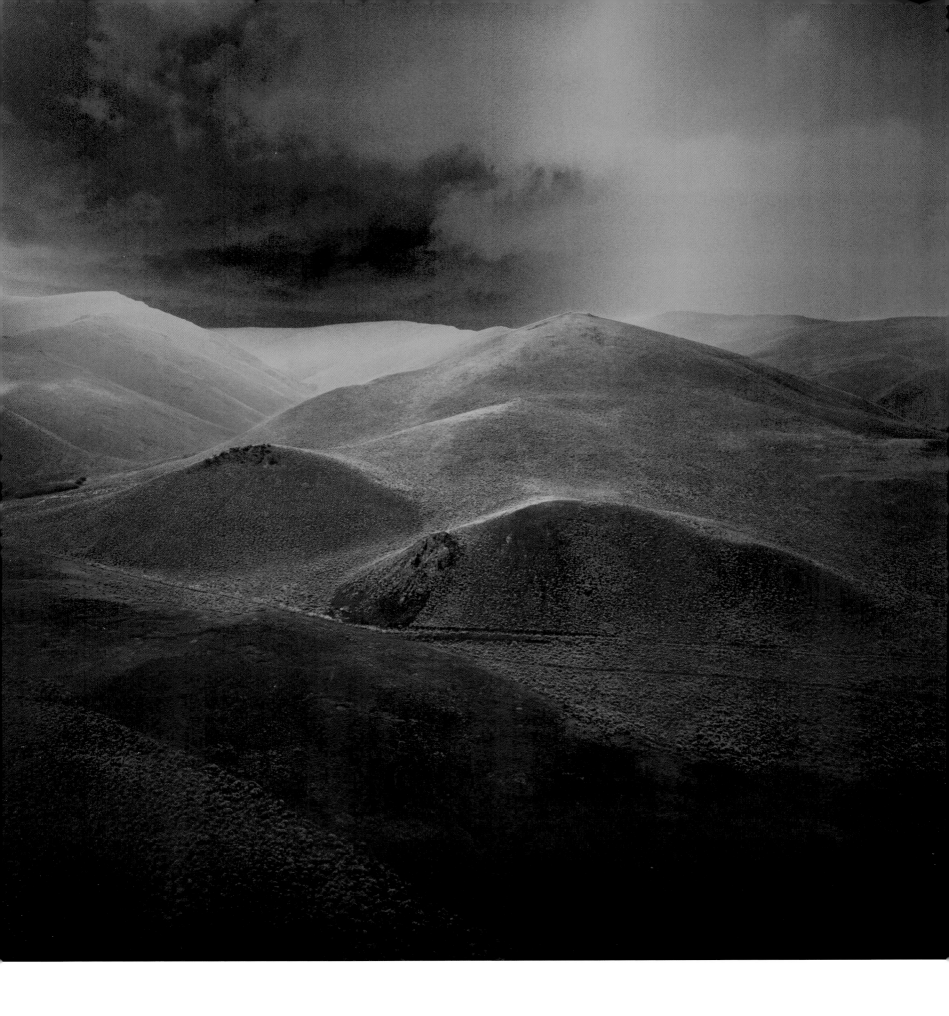

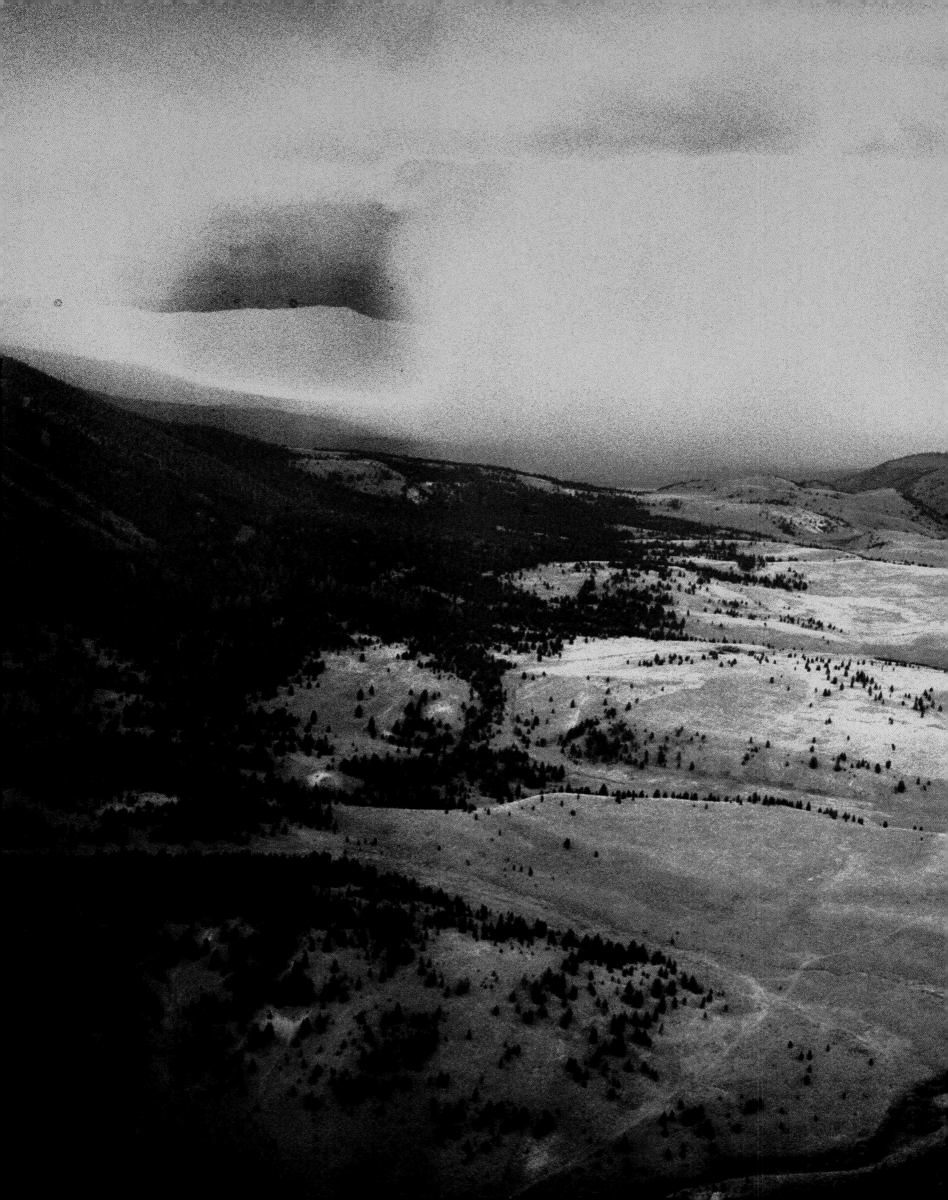

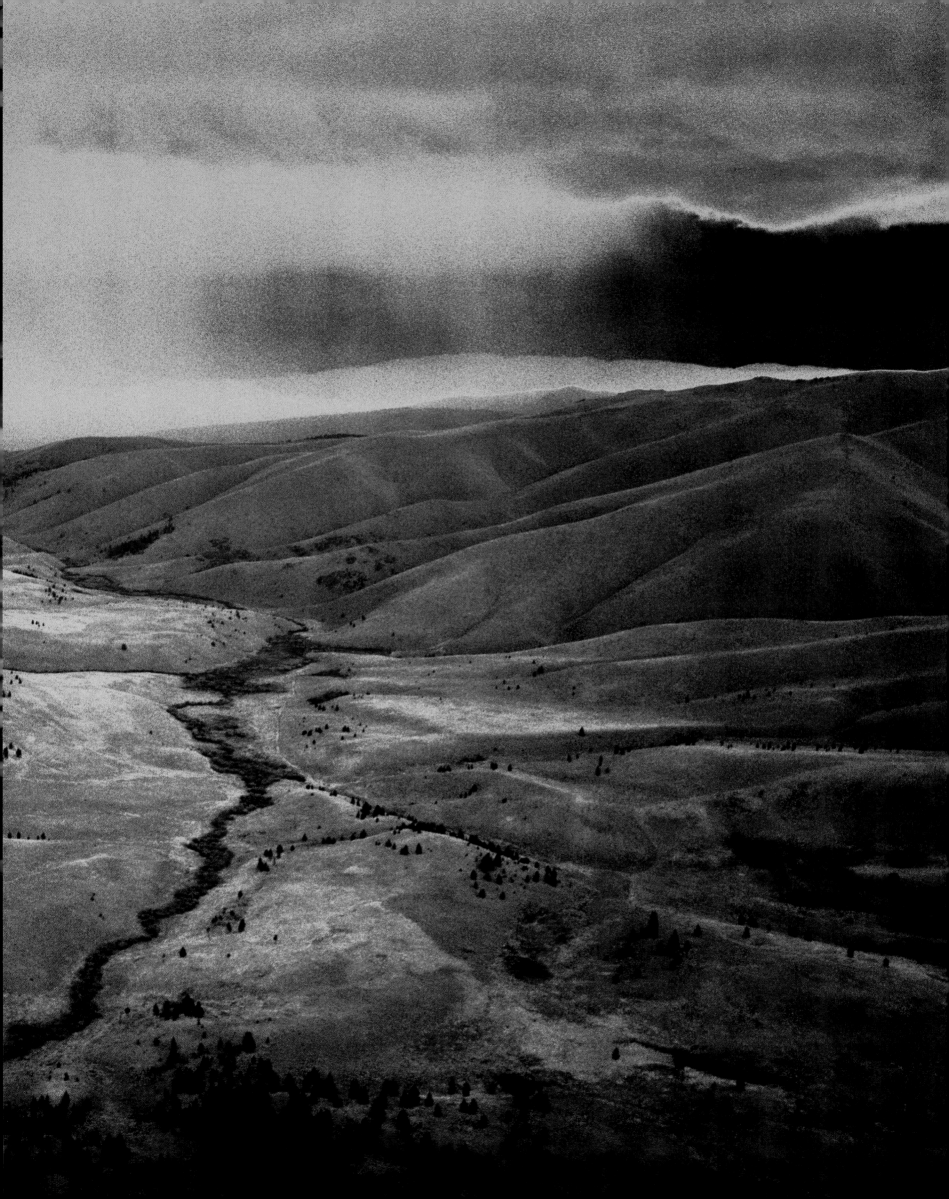

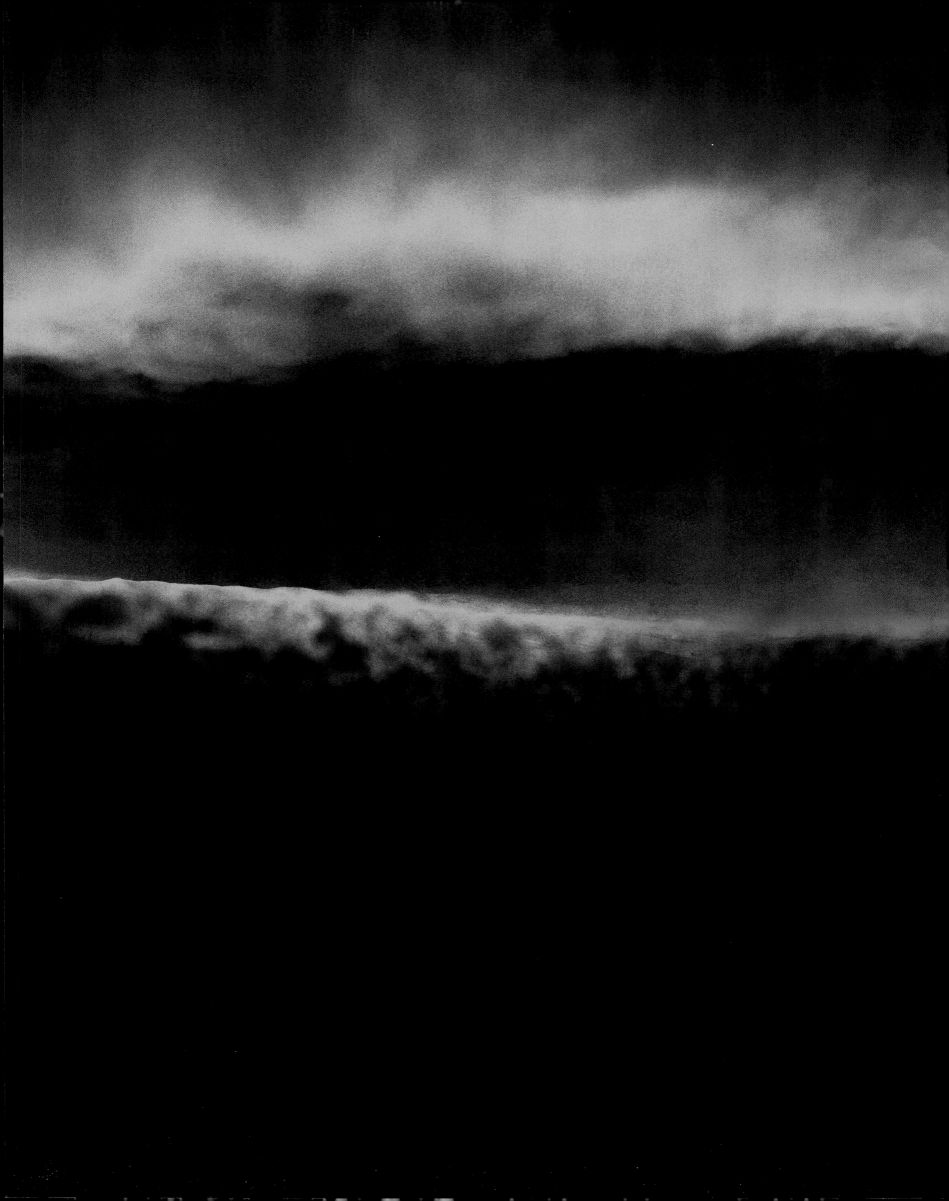

UPHEAVAL DOME

38° 26' N, 109°54' W

Location: UTAH, UNITED STATES

Diameter: 6 KILOMETERS

Crater type: COMPLEX CRATER WITH CENTRAL UPLIFT

Age: UNKNOWN, BUT <200 MILLION YEARS

Geological condition: DEEPLY ERODED

Impact evidence: SHOCKED QUARTZ, STRUCTURAL EVIDENCE

Meteorite type: UNKNOWN

The deeply incised circular canyon of this highly eroded crater features rocks of Triassic and Jurassic age, dipping chaotically in all directions. Despite its impact craterlike appearance, confirming its impact origin was difficult. For many years scientists believed the structure to be a salt dome. Only in 2008 was definitive proof of an impact origin found in the form of shocked minerals.

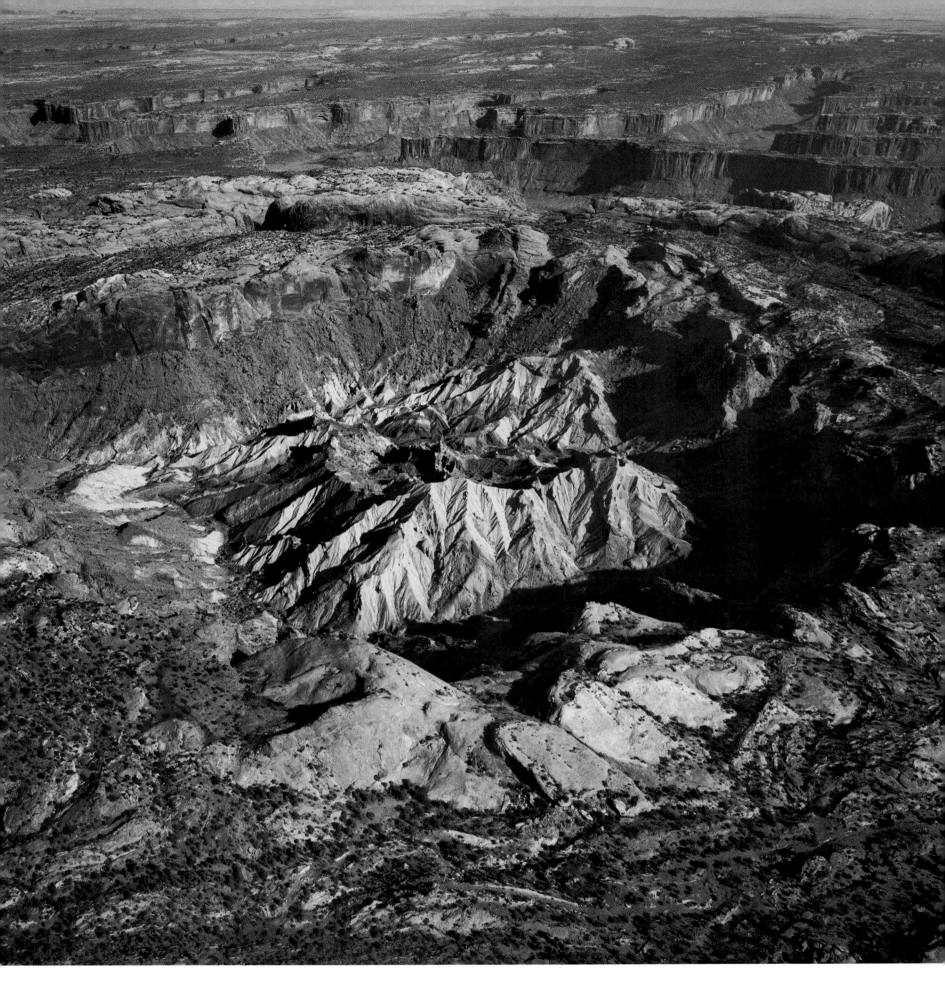

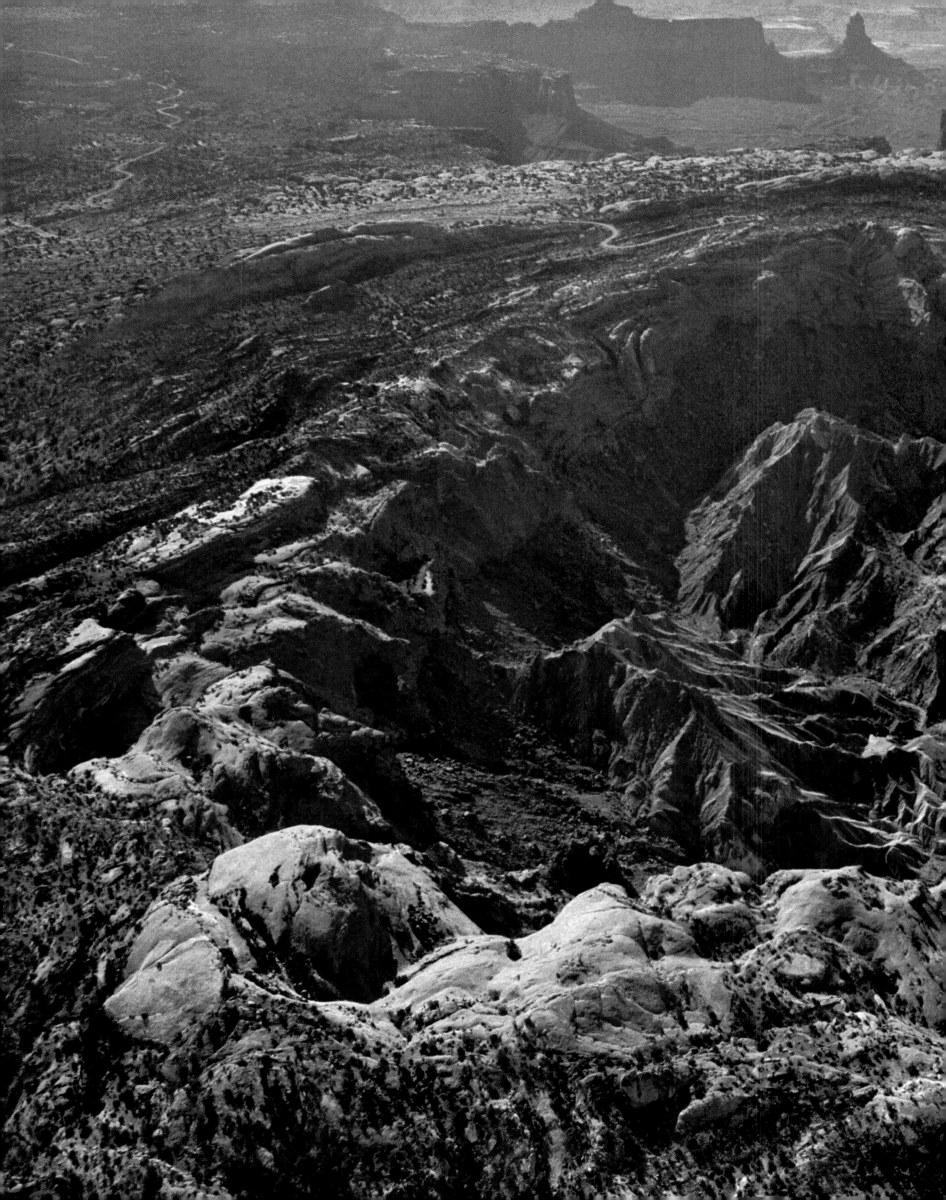

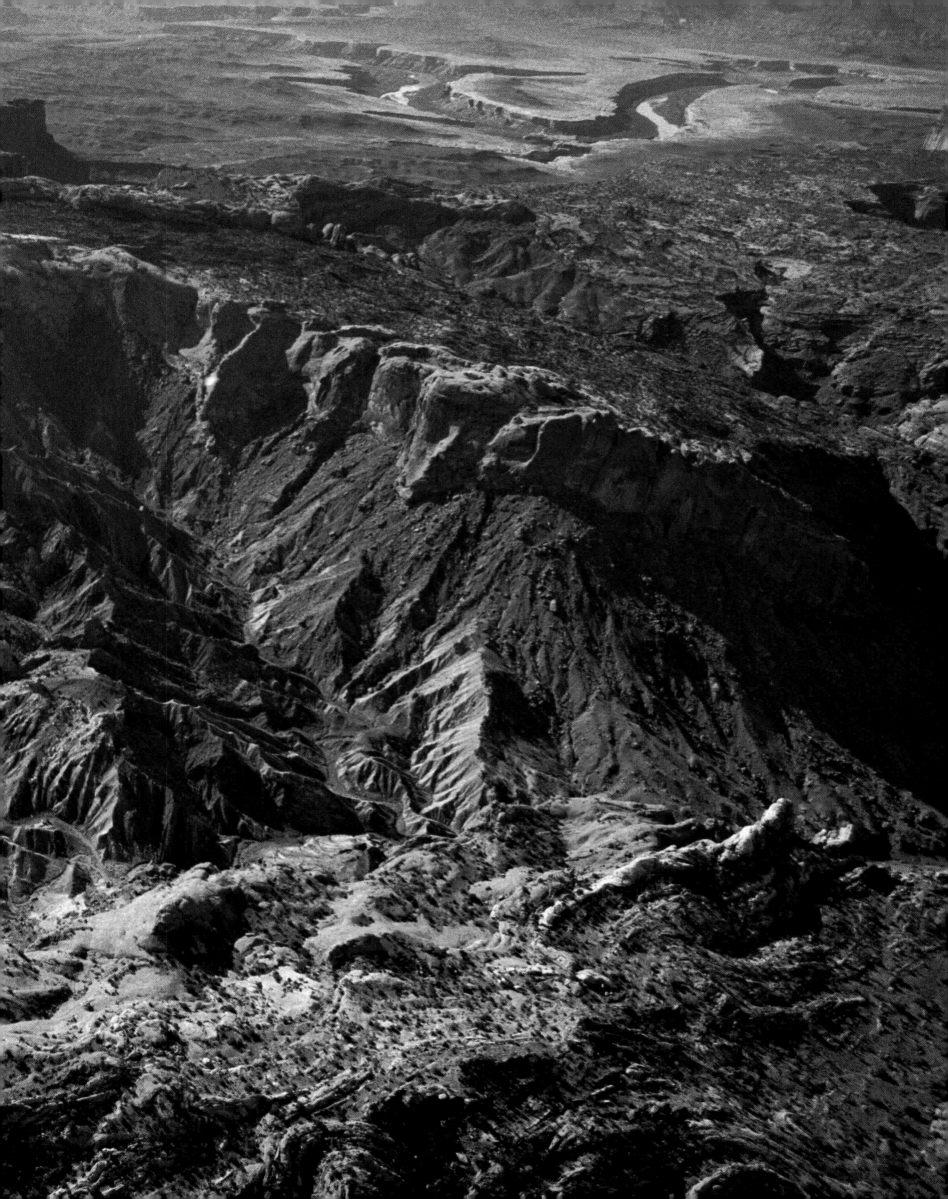

GOSSES BLUFF

23°49'S, 132°19'E

Location: NORTHERN TERRITORY, AUSTRALIA

Diameter: 22 KILOMETERS

Crater type: COMPLEX CRATER WITH CENTRAL UPLIFT

(APPROX. 6 KILOMETERS IN DIAMETER)

Age: 142.5 MILLION YEARS

Geological condition: DEEPLY ERODED

Impact evidence: SHATTER CONES, SHOCKED MINERALS

Meteorite type: UNKNOWN

In the desert near Alice Springs lies this deeply eroded impact site. The only part that remains exposed is an equally eroded central uplift, weathered down to a ring structure (not to be confused with a crater rim). In the central uplift, shatter cones are exposed.

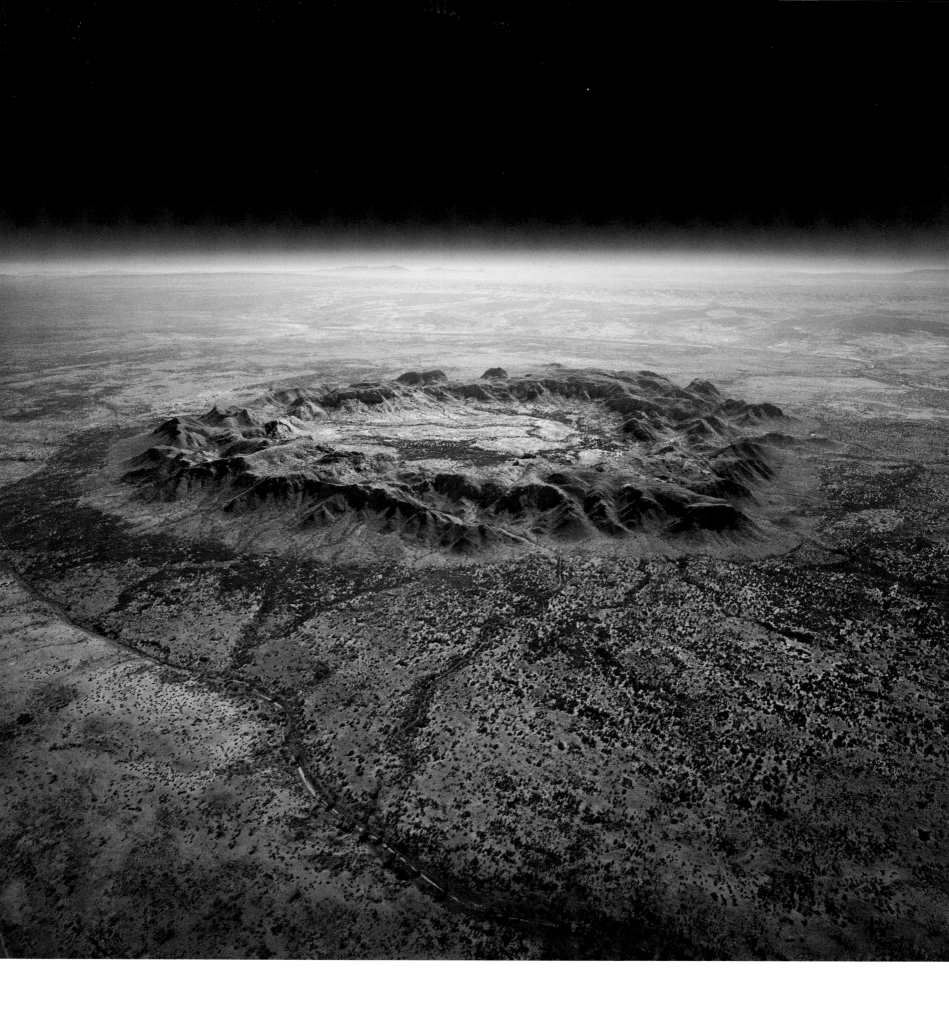

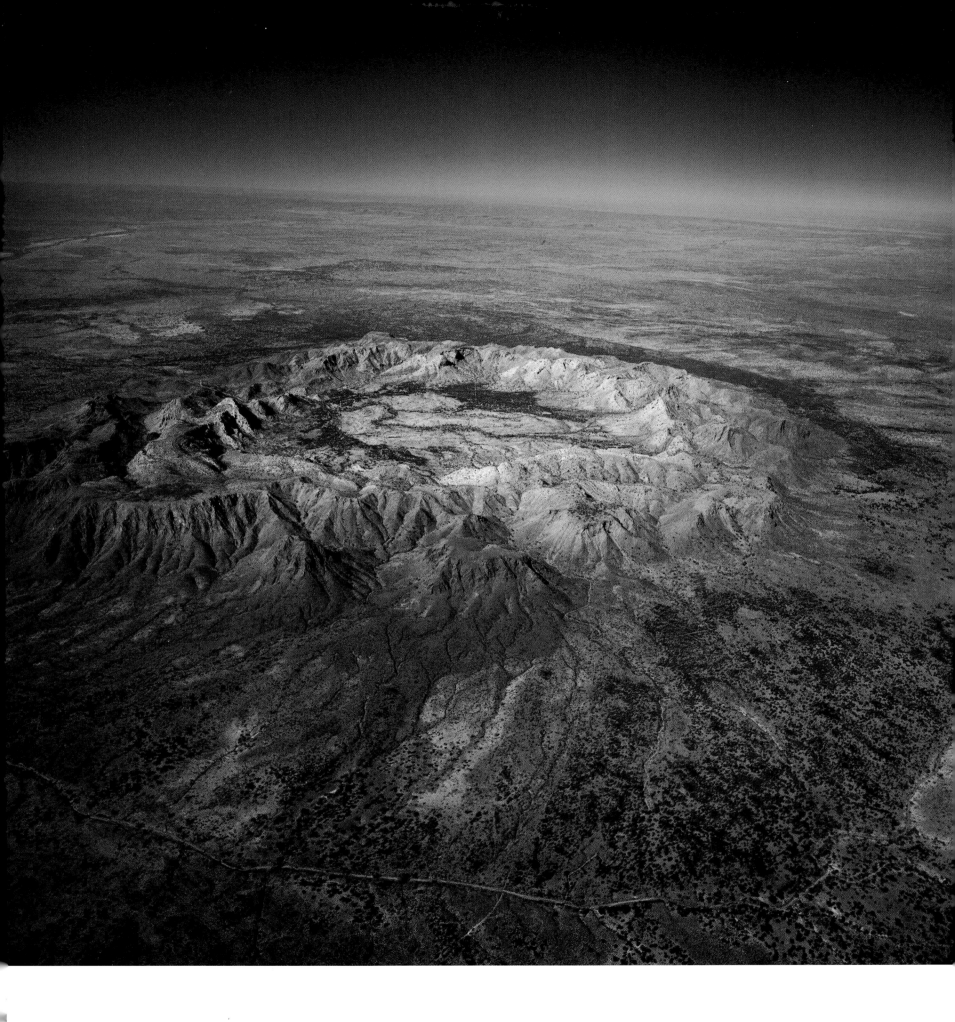

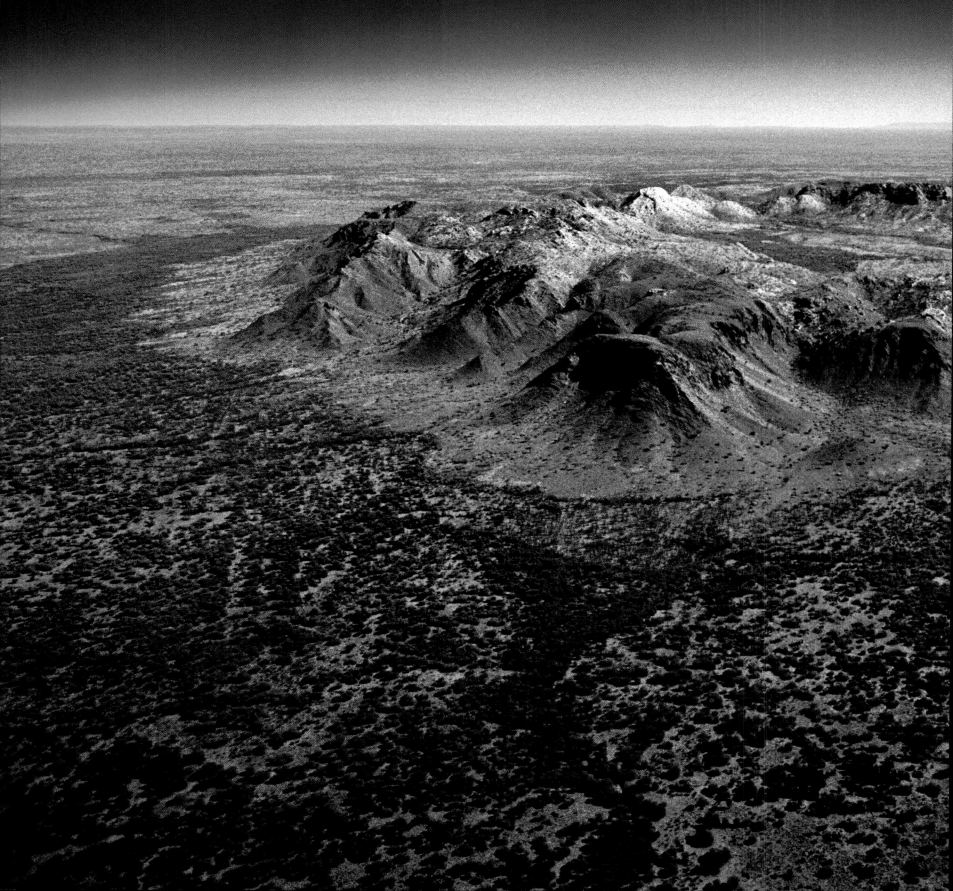

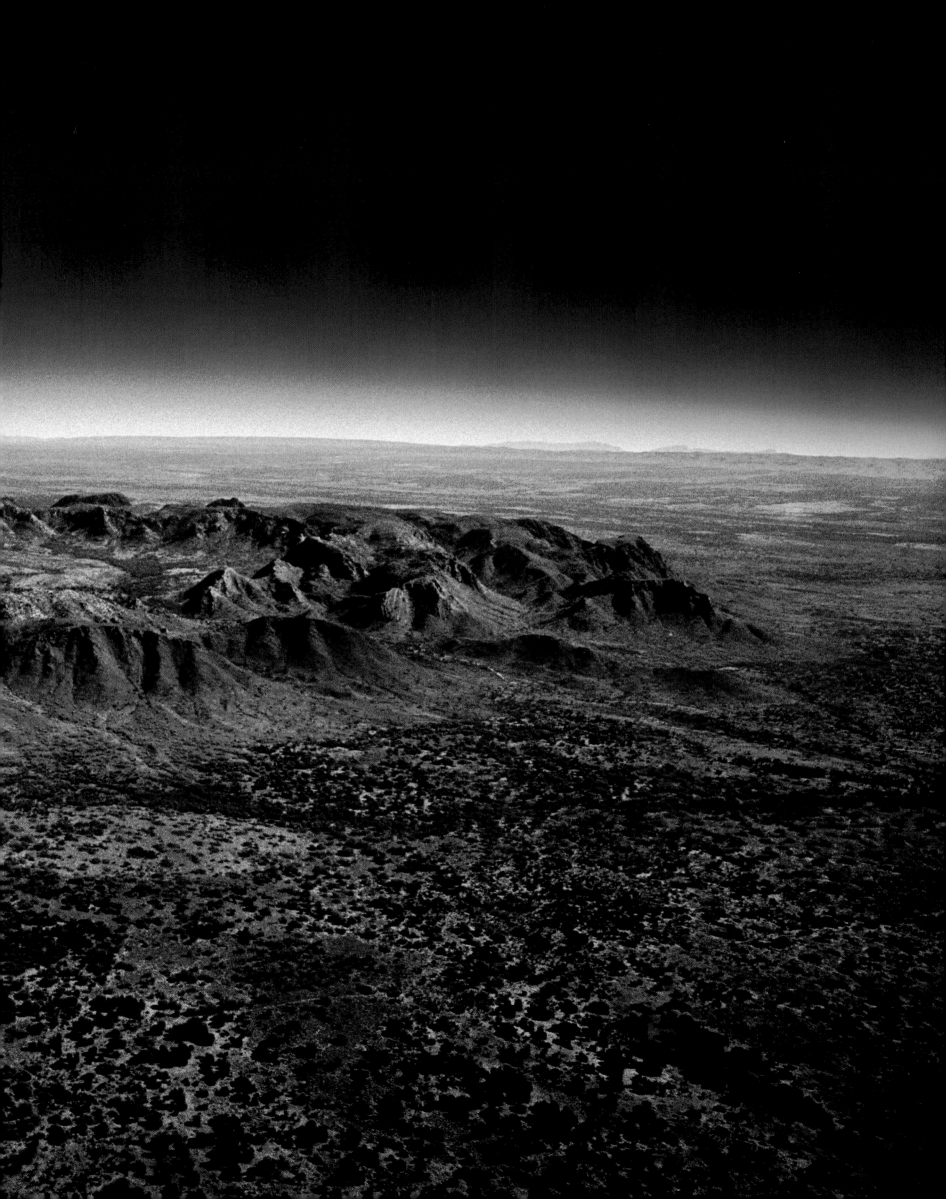

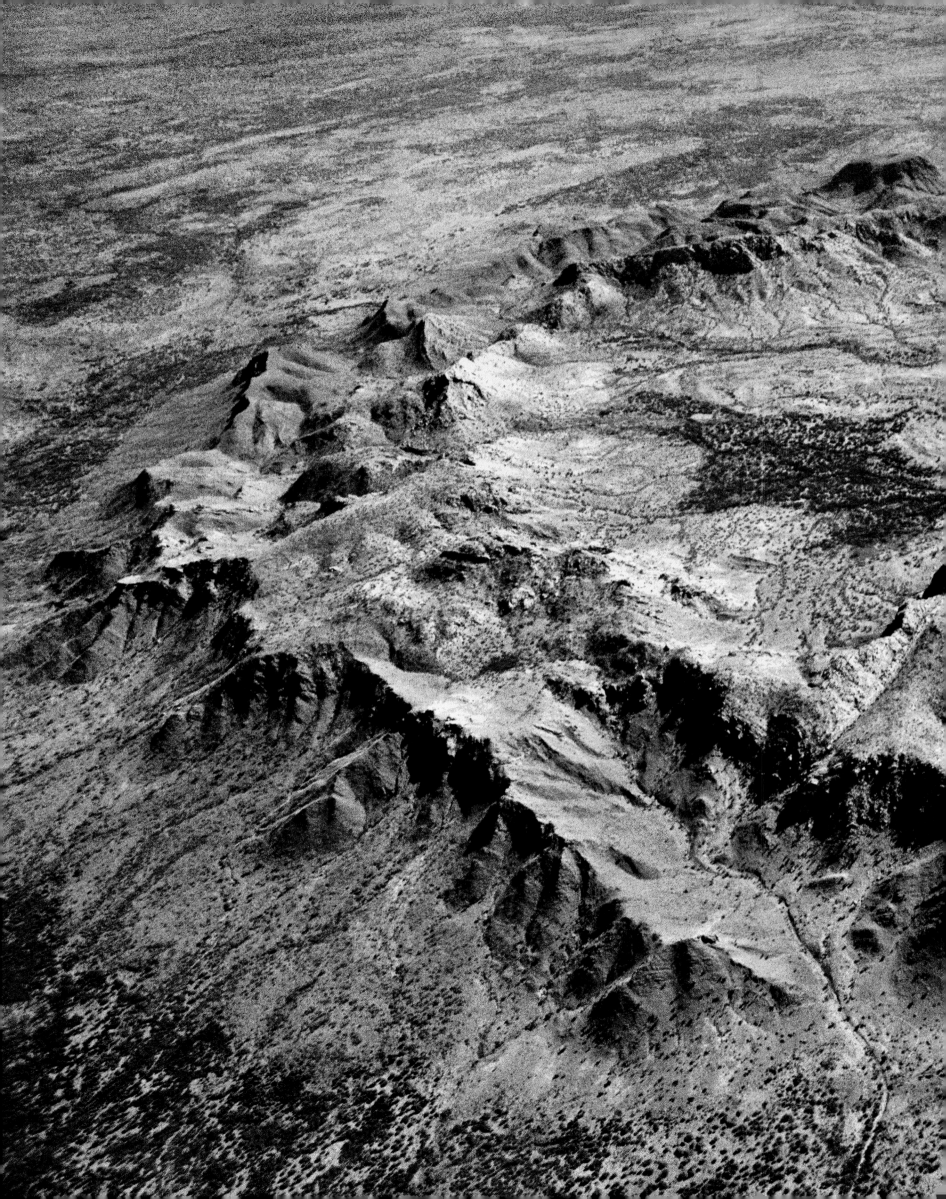

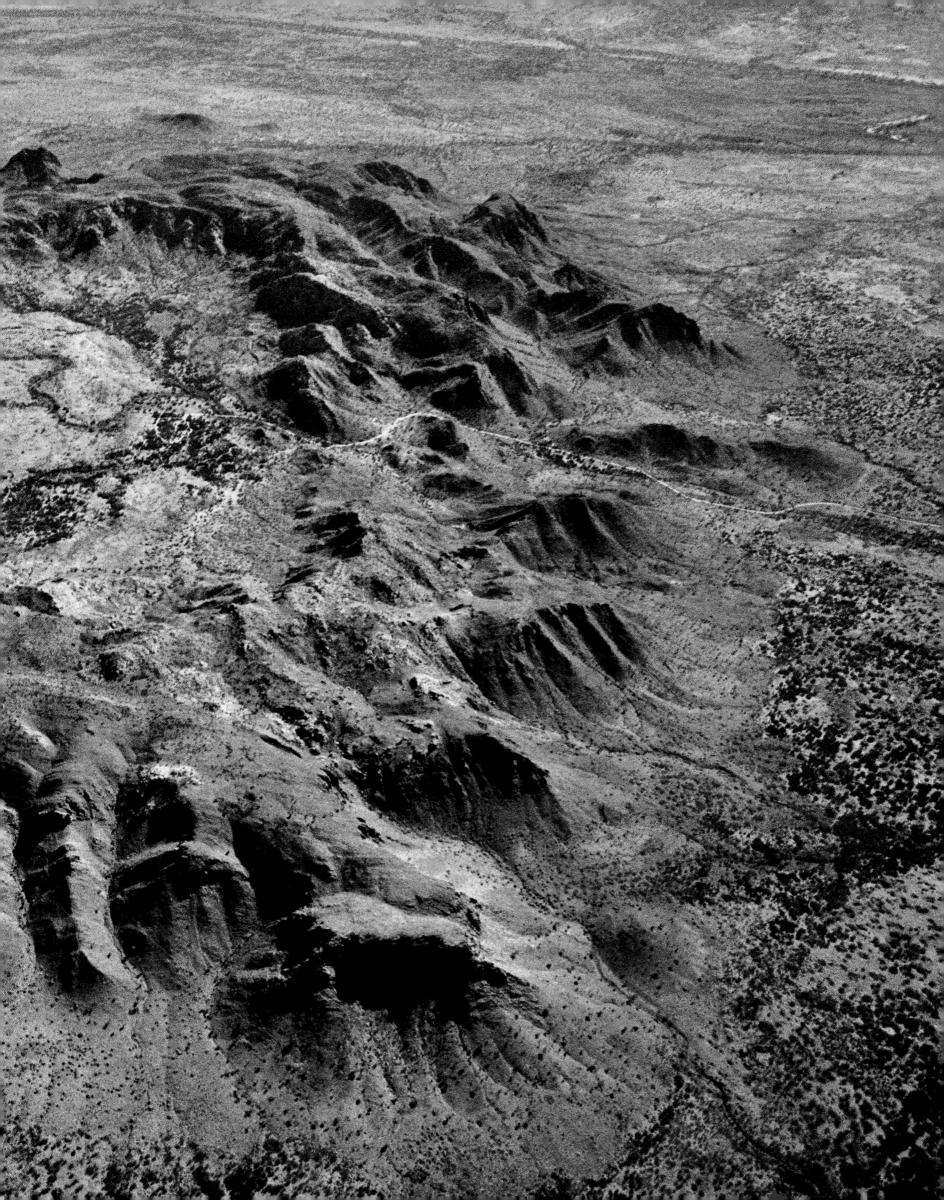

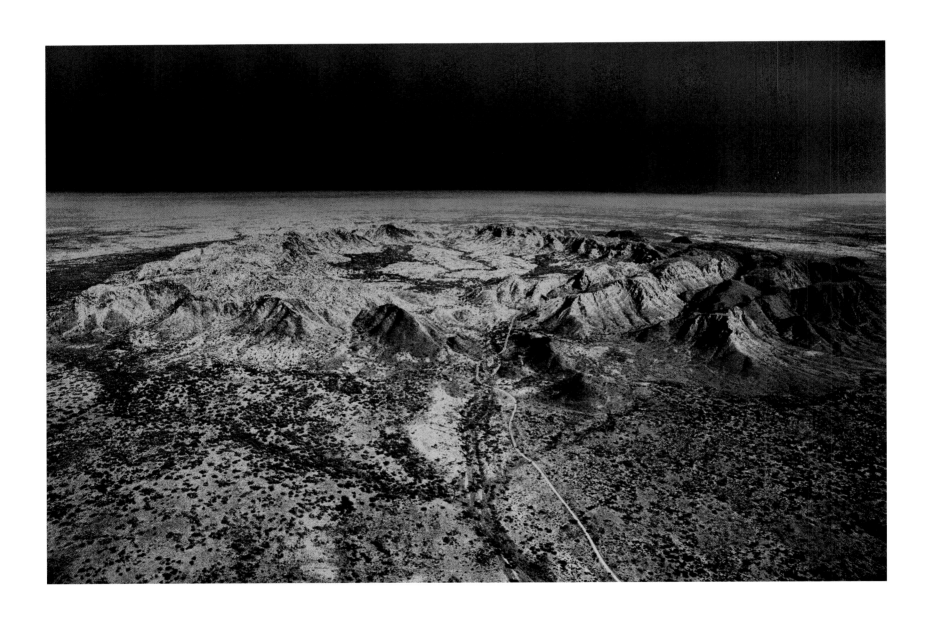

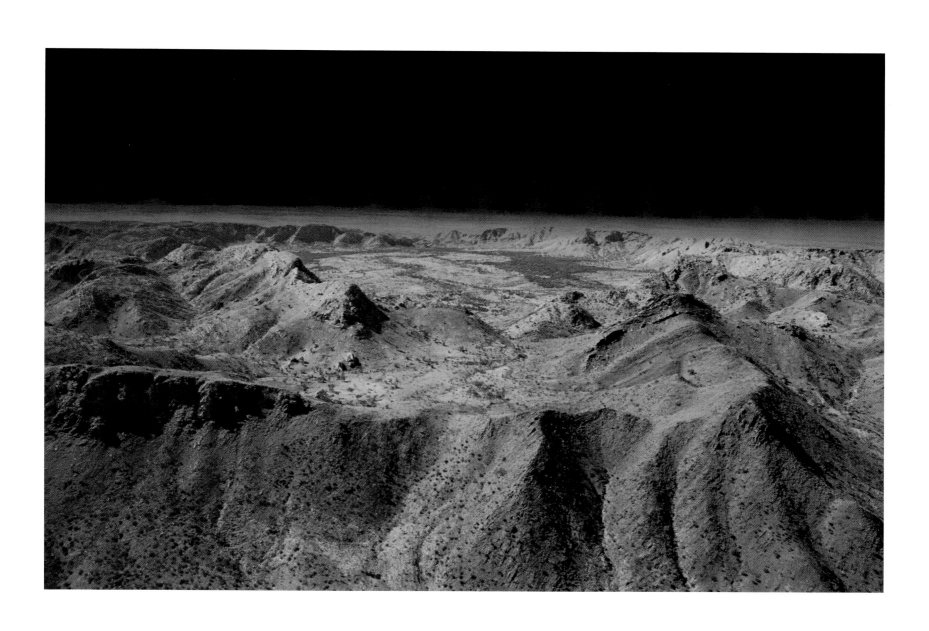

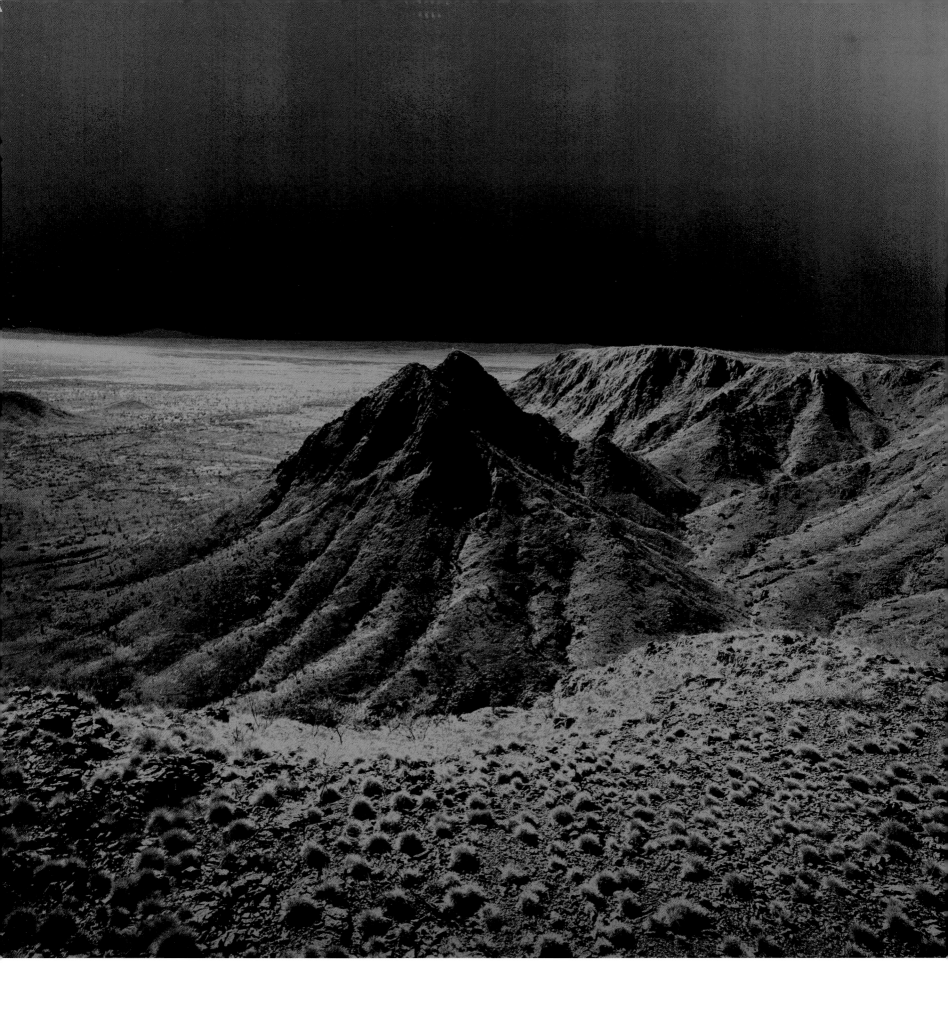

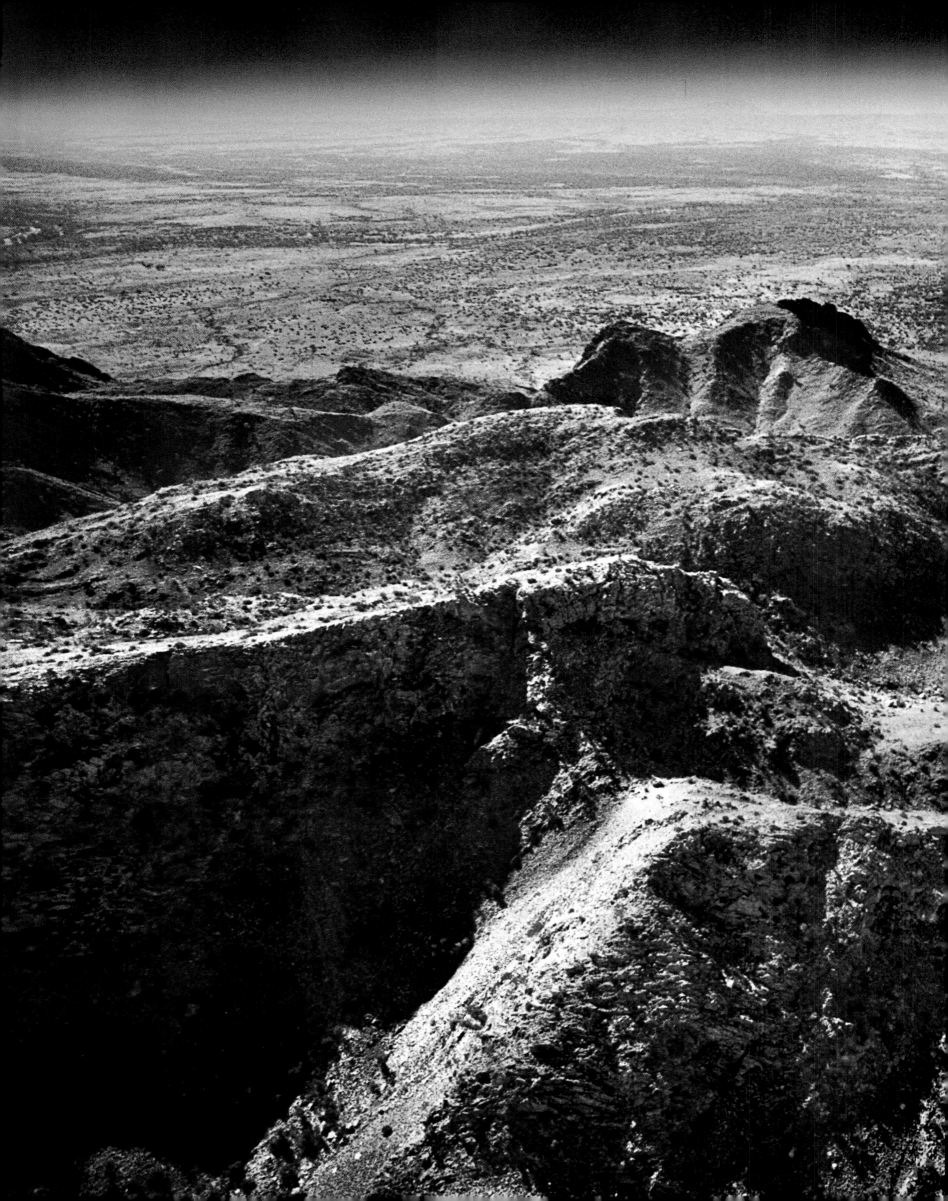

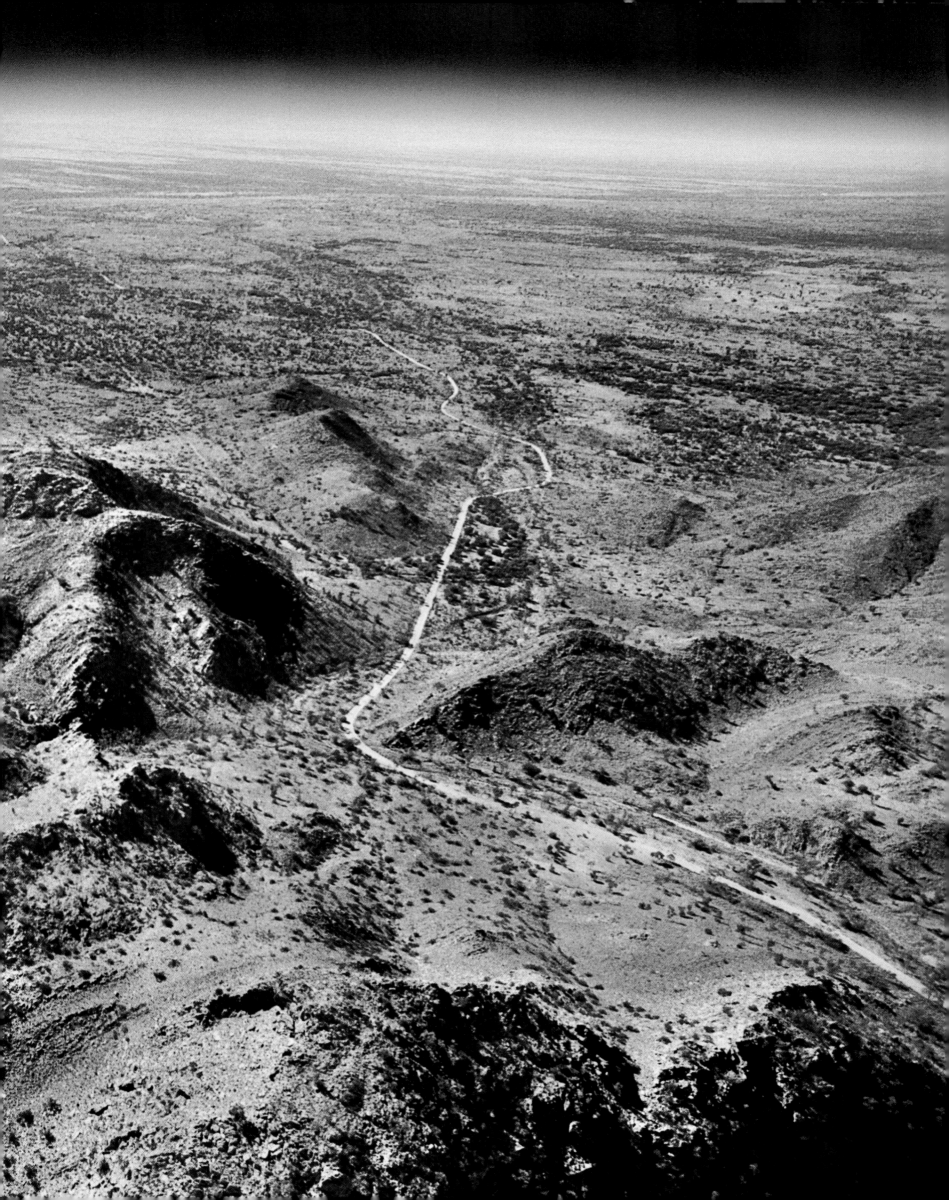

ROTER KAMM

27°46'S, 16°18'E

Location: NAMIBIA

Diameter: 2.5 KILOMETERS

Crater type: SIMPLE CRATER

Age: 3.7 MILLION YEARS

Geological condition: SLIGHTLY ERODED, FILLED WITH SAND

Impact evidence: SHOCKED MINERALS, MELT ROCKS

Meteorite type: STONY METEORITE (CHONDRITE)

Located in a restricted diamond zone in the southern Namib Desert, Roter Kamm is difficult
to access. The crater is partially filled with sand; only the rim is exposed and available
for geological exploration. Ground radar studies show that shattered, shocked,
and brecciated rocks were thrown several kilometers from the crater rim during the
impact event, but these deposits are now covered by sand.

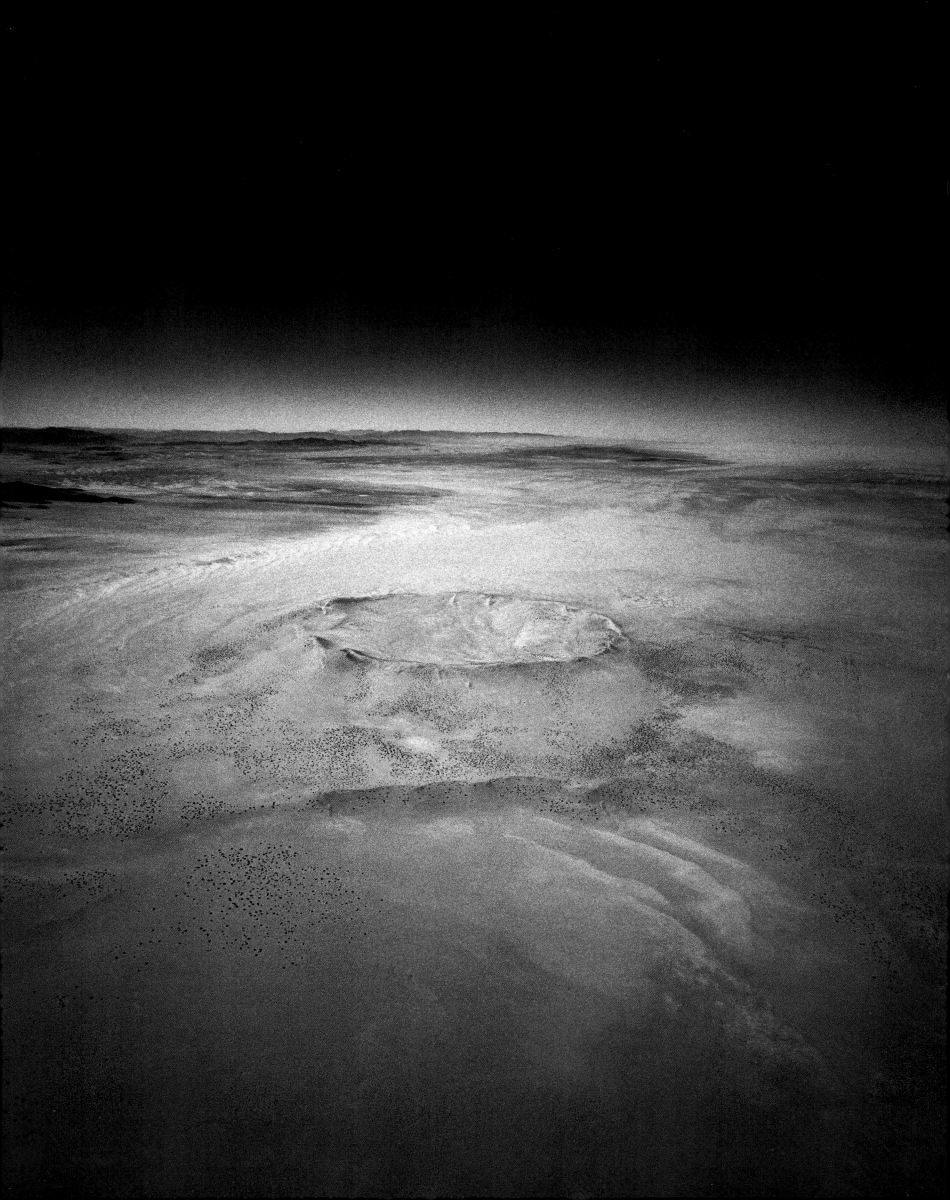

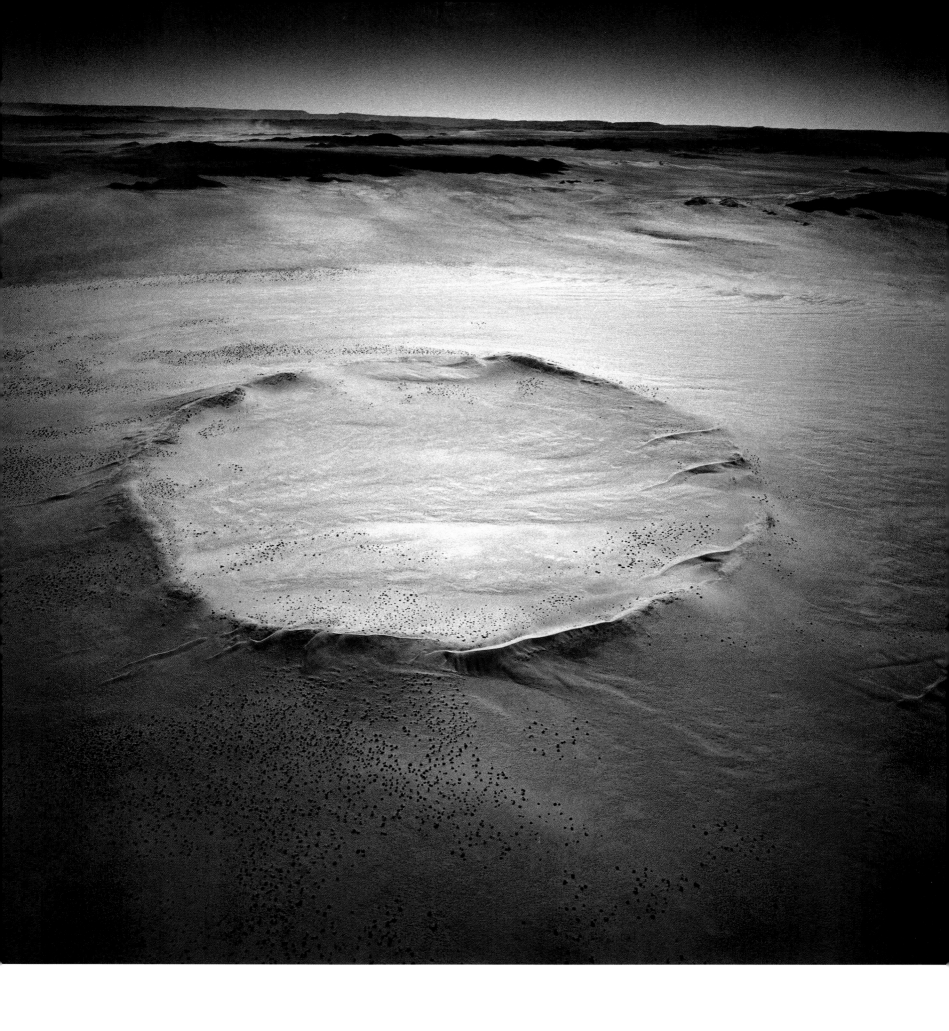

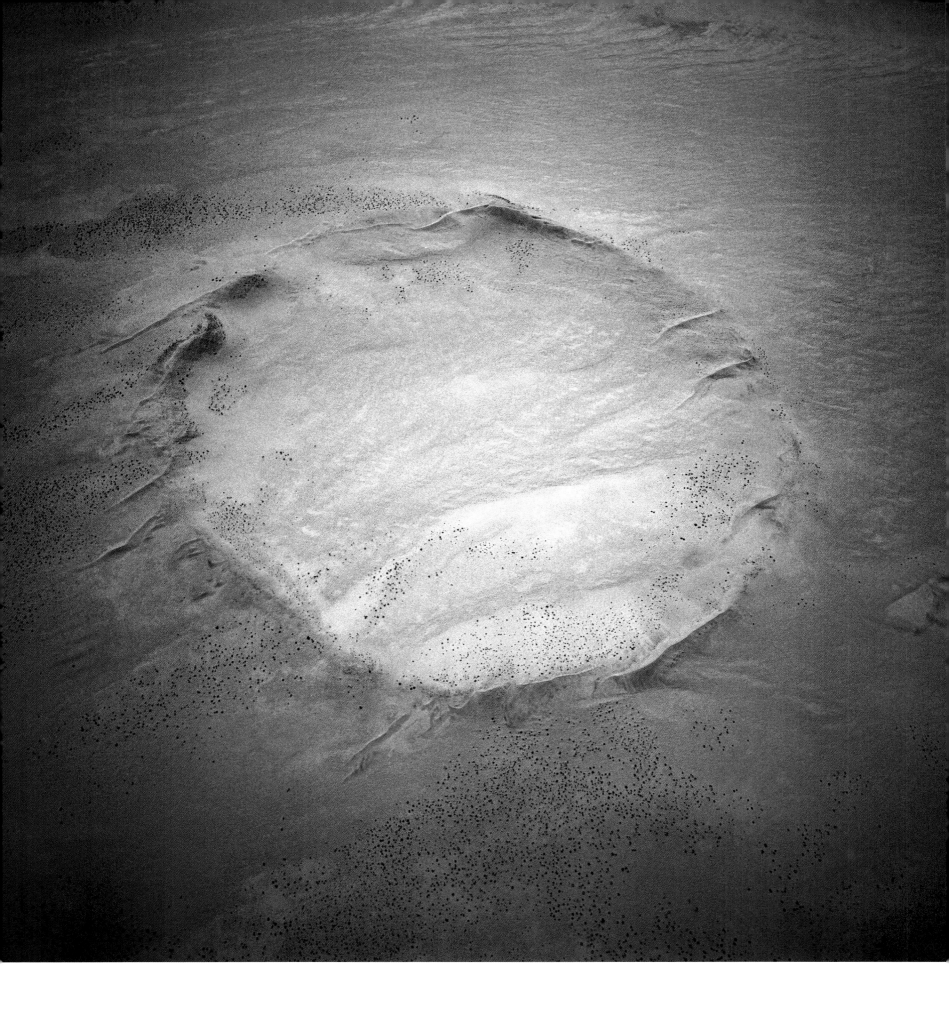

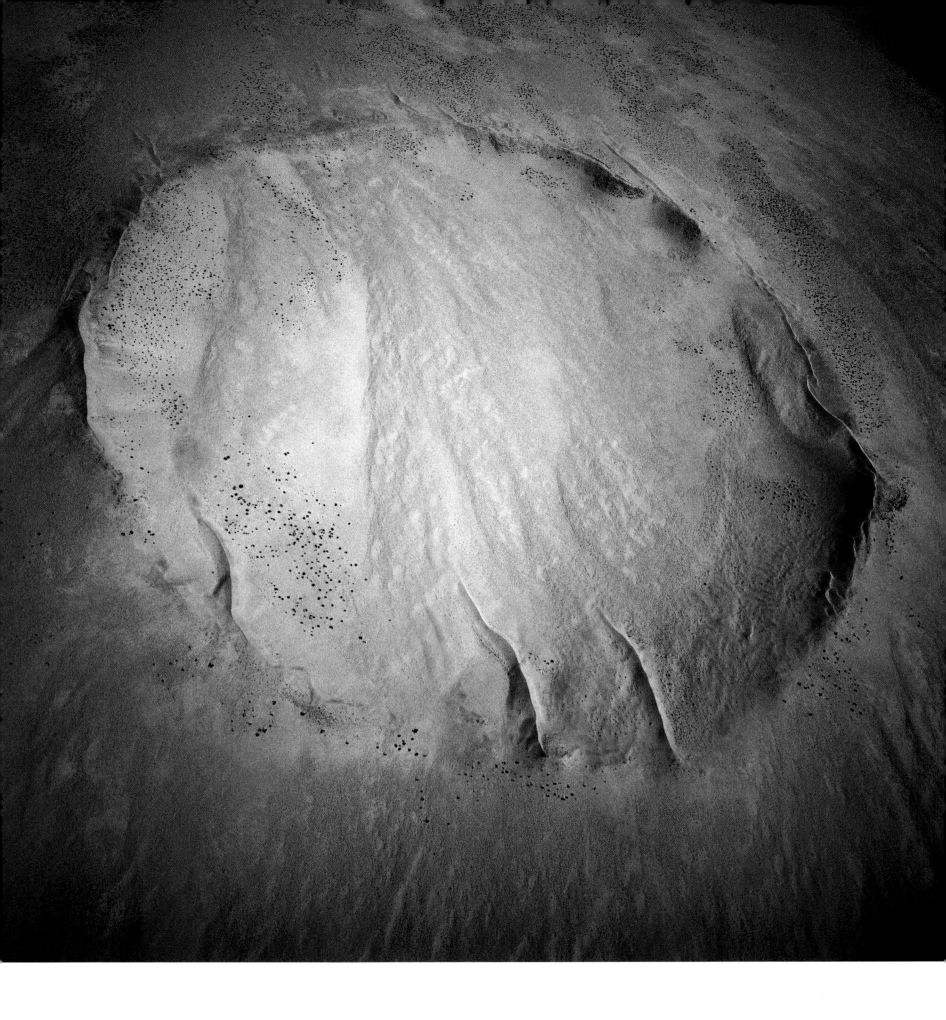

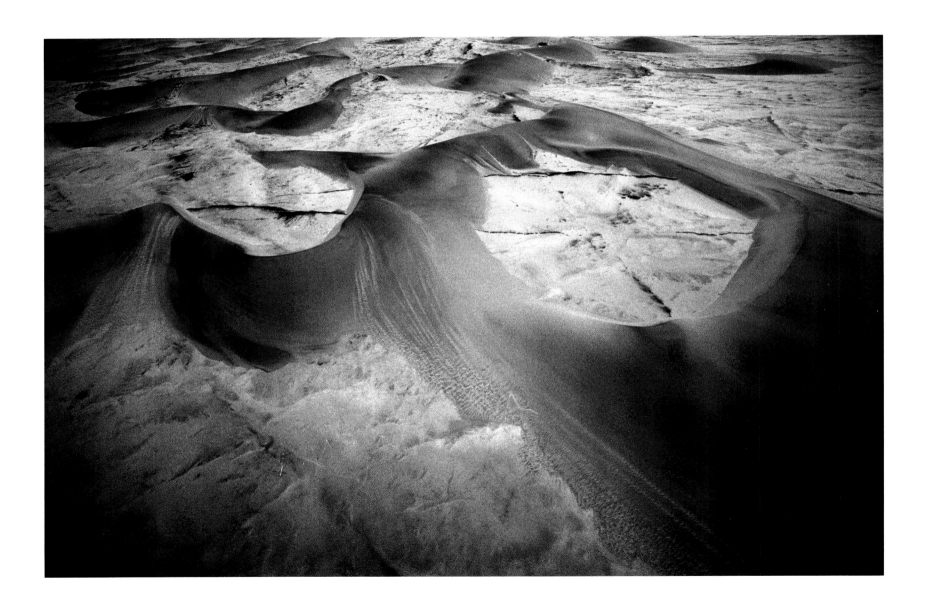

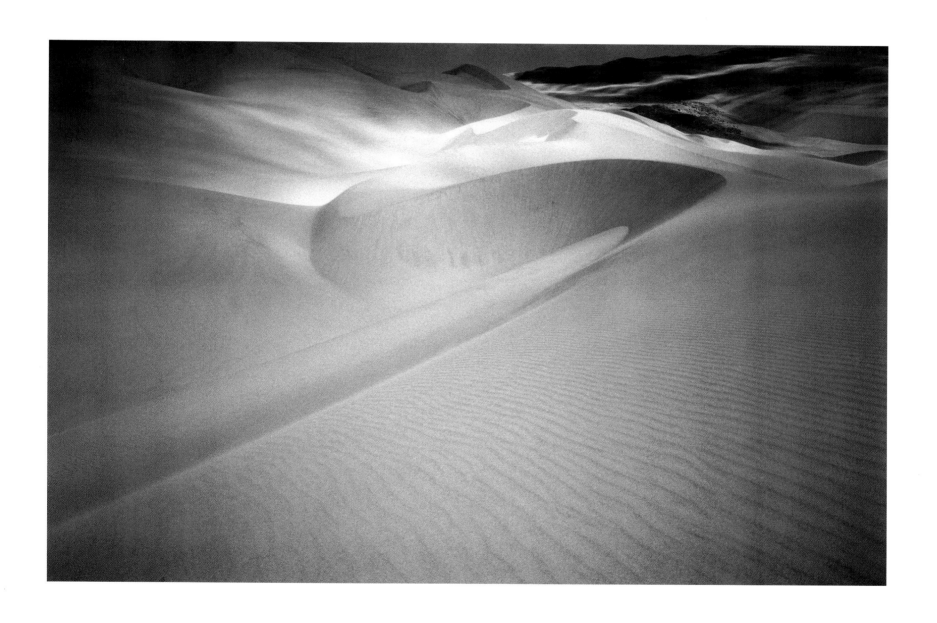

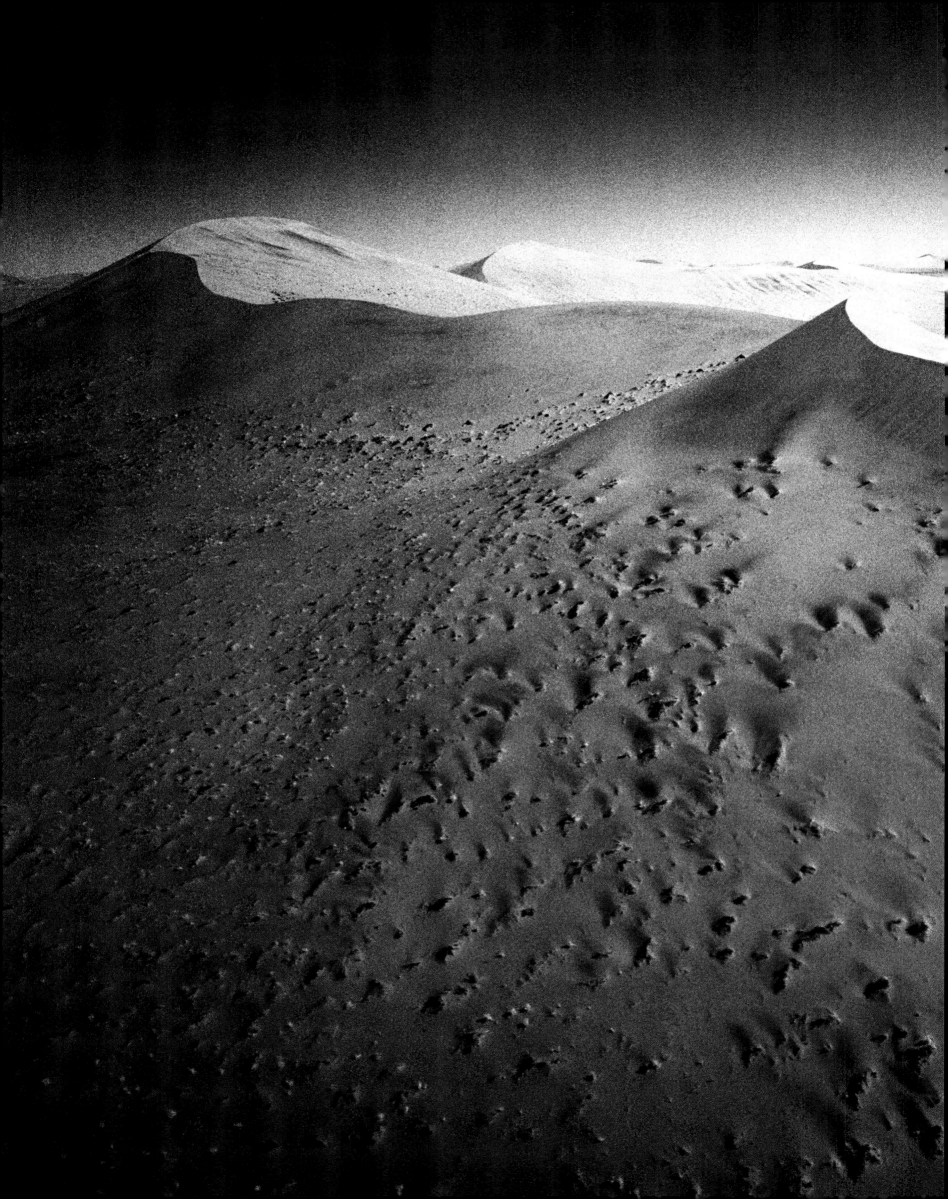

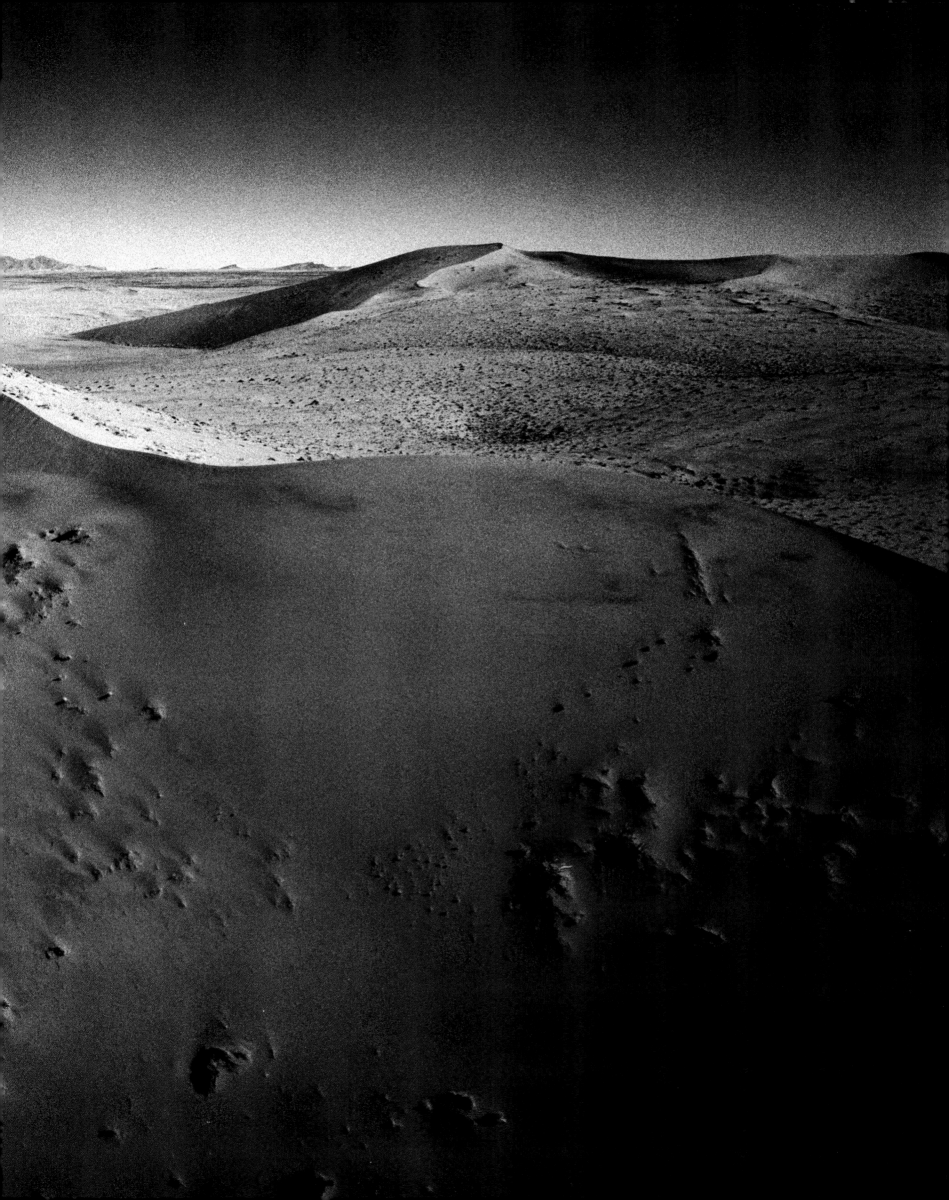

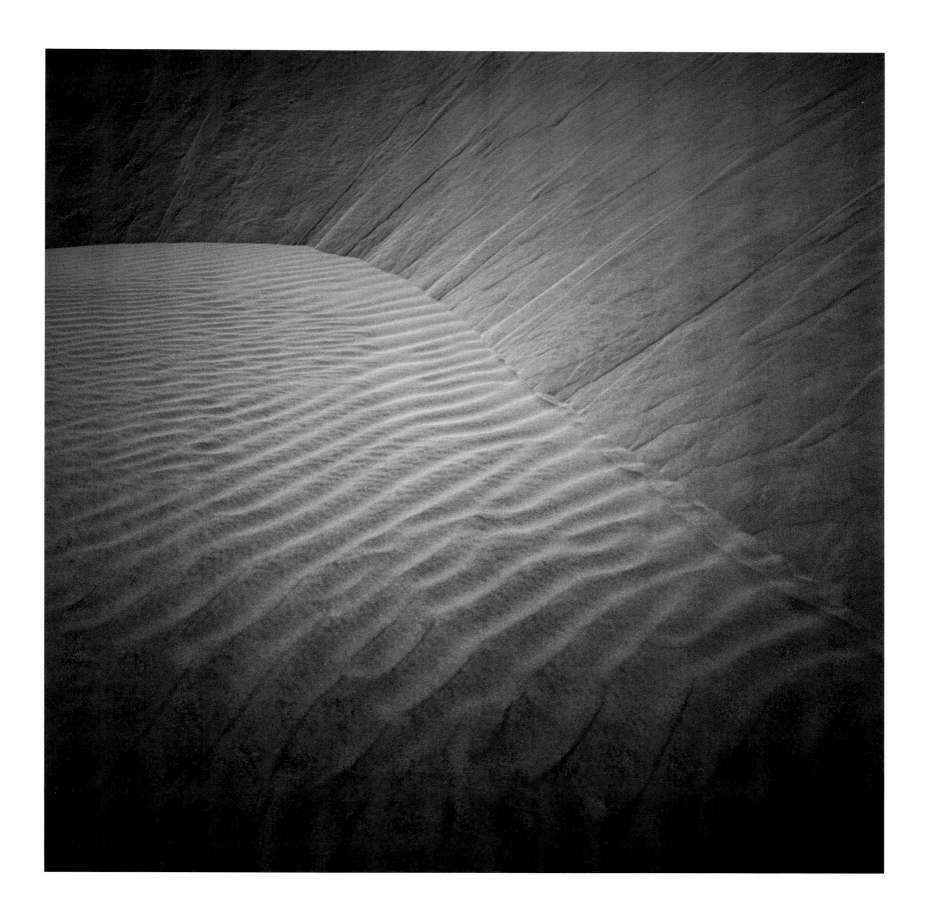

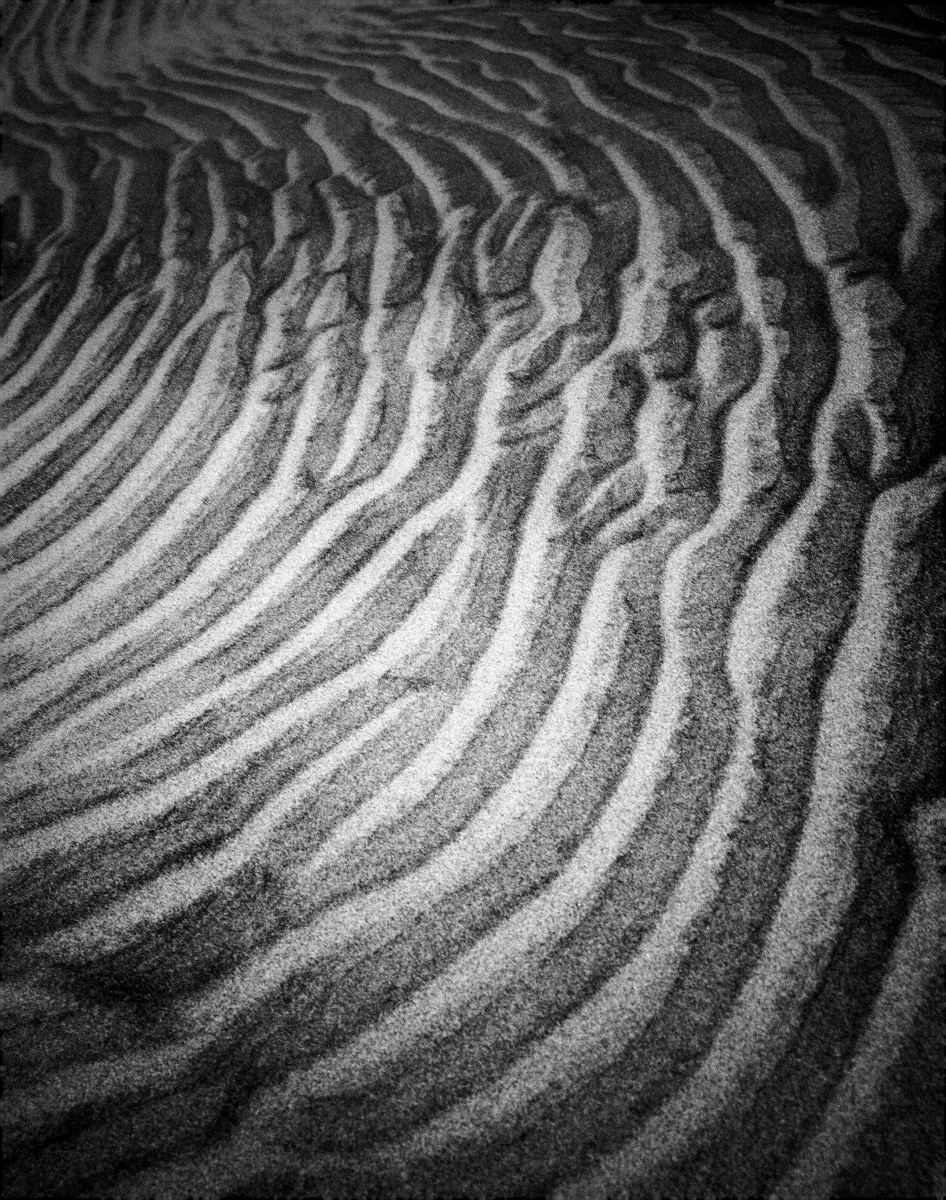

NEW QUEBEC

61°17'N, 73°40'W

Location: QUEBEC, CANADA

Diameter: 3.4 KILOMETERS

Crater type: SIMPLE CRATER

Age: 1.4 MILLION YEARS

Geological condition: SLIGHTLY ERODED RIM

Impact evidence: SHOCKED MINERALS, MELT ROCKS

Meteorite type: STONY METEORITE (L-TYPE CHONDRITE)

This relatively young crater was discovered from the air in 1943. It is sometimes referred to as Pingualuit or Chubb crater, the latter, after diamond prospector Fred Chubb, who visited the site in 1950. A simple crater, its bowl shape is mostly filled with water, forming a lake with depths up to 270 meters. The crater's rim rises to approximately 160 meters above the lake's surface and has been somewhat eroded by glacial action. Melt rocks can still be found, however, along the lake's shore.

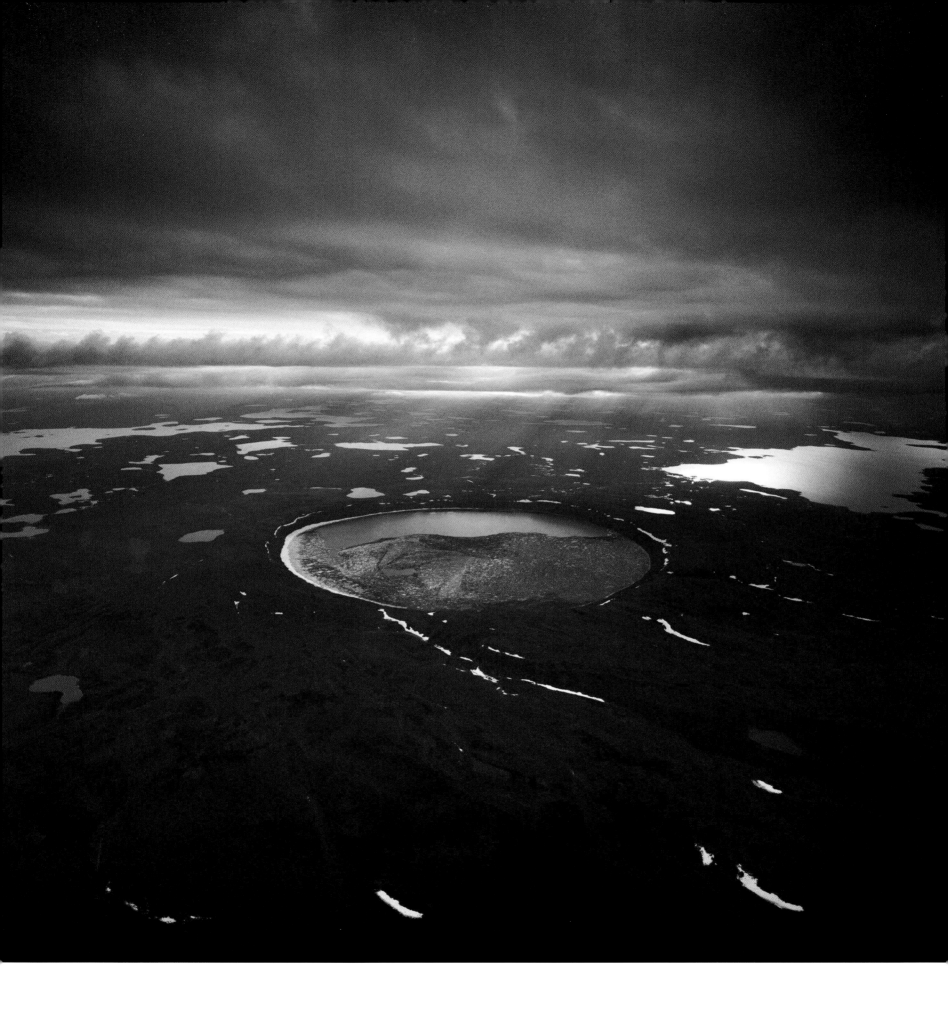

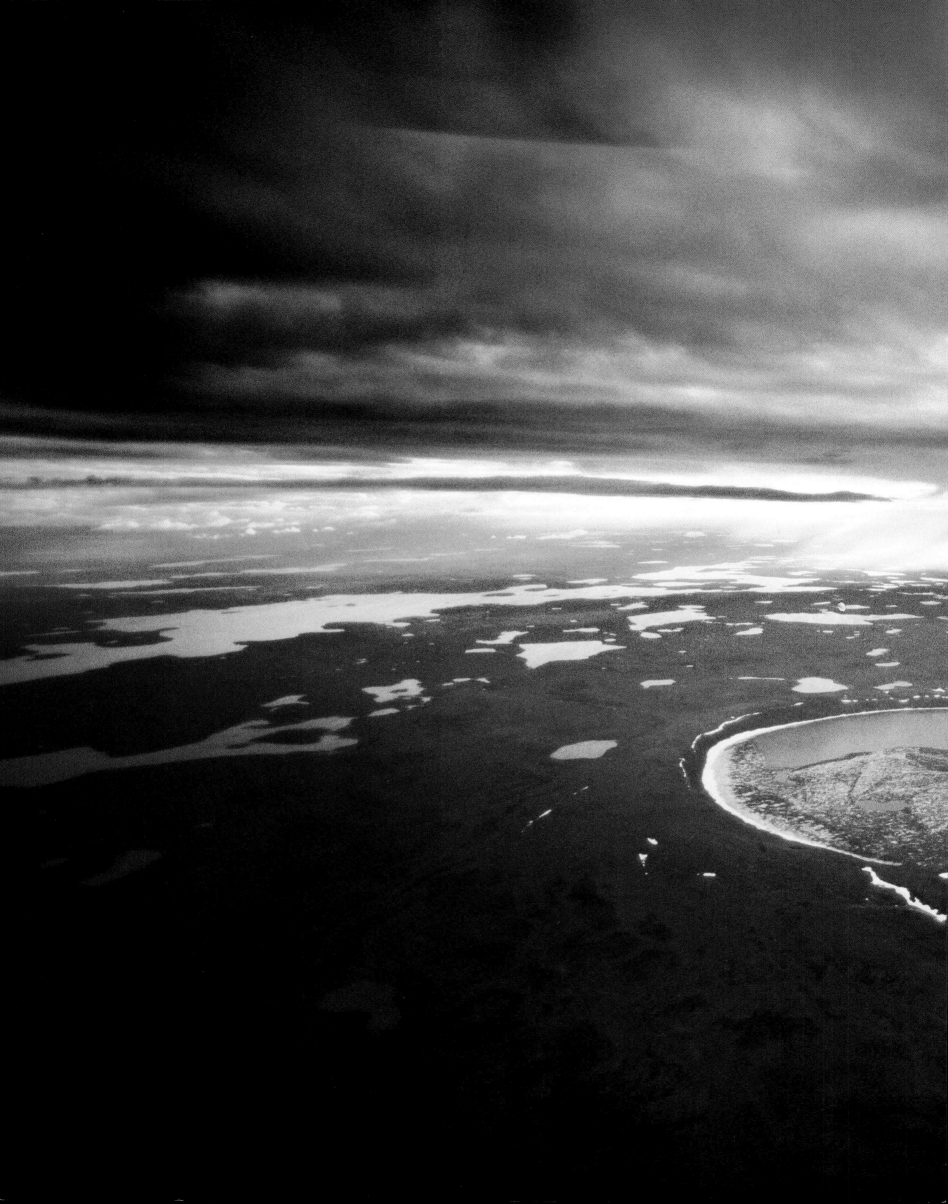

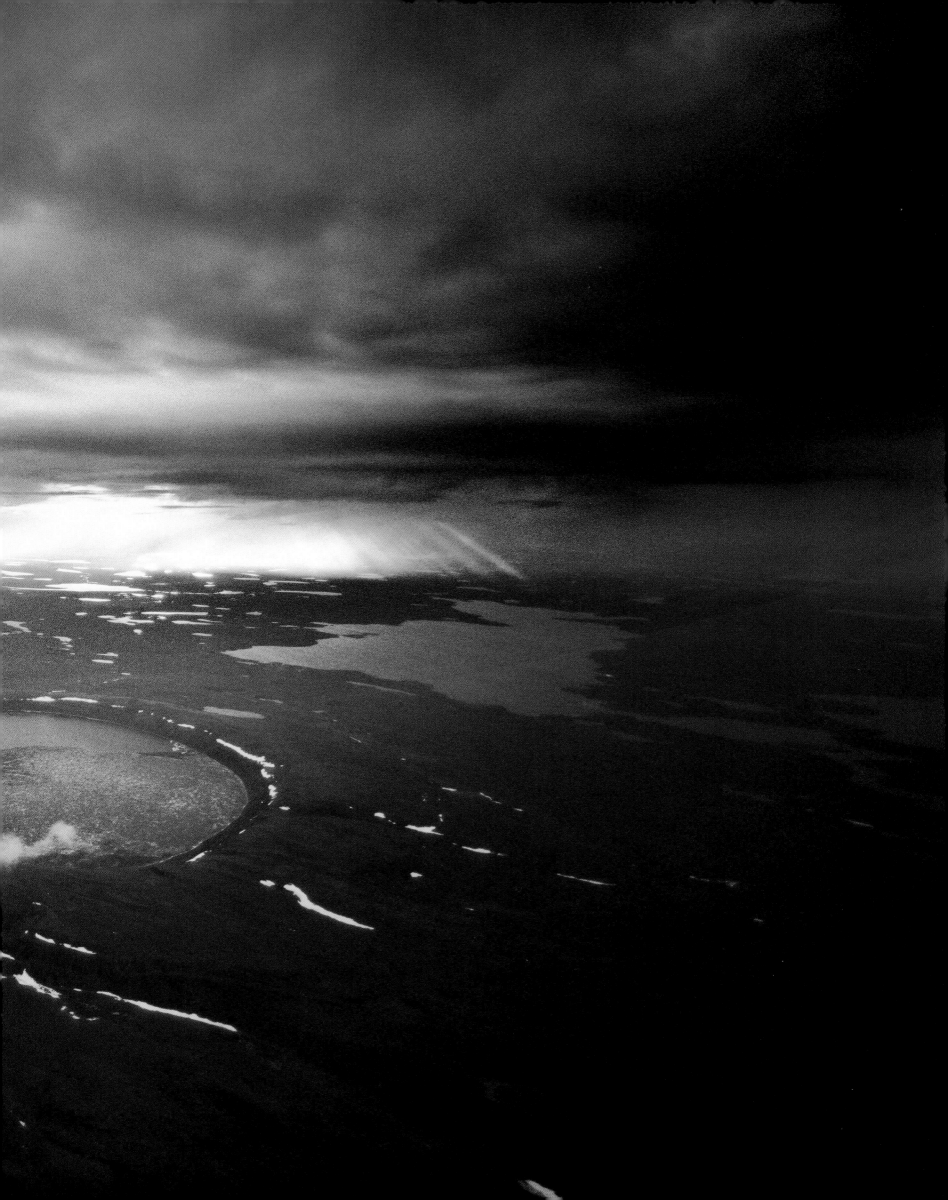

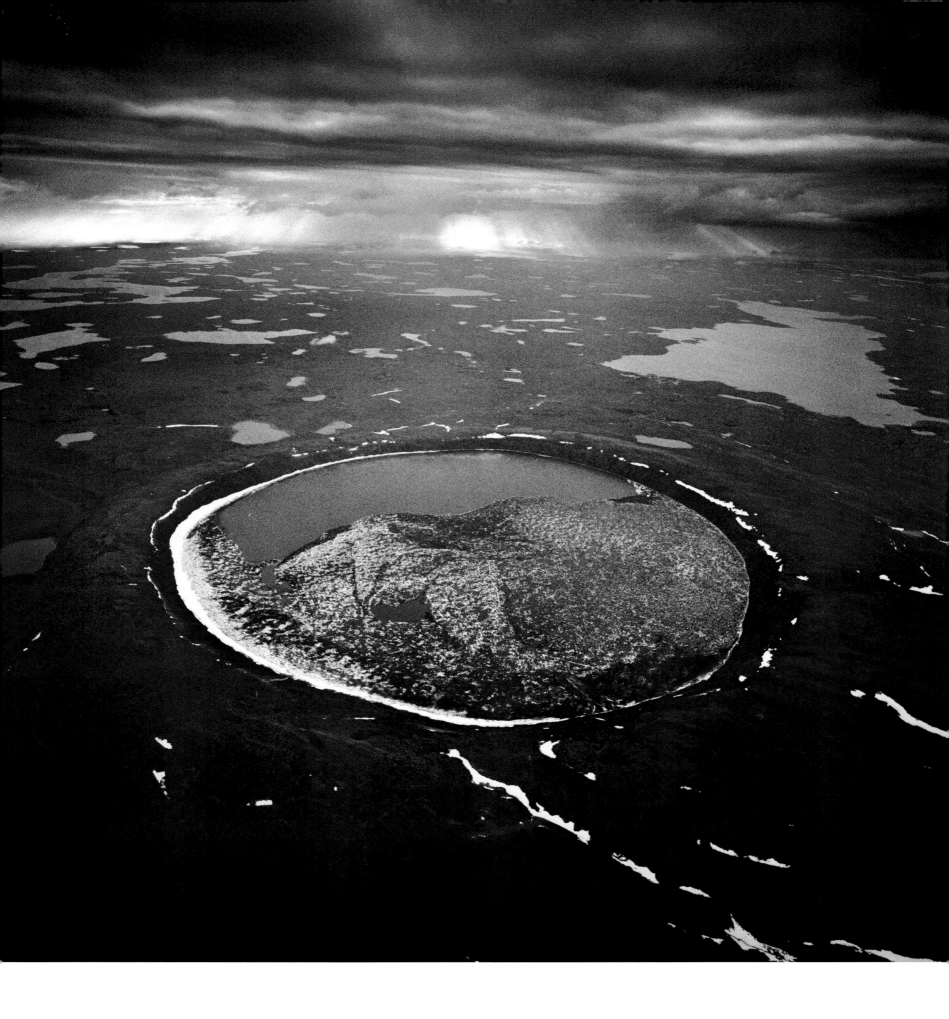

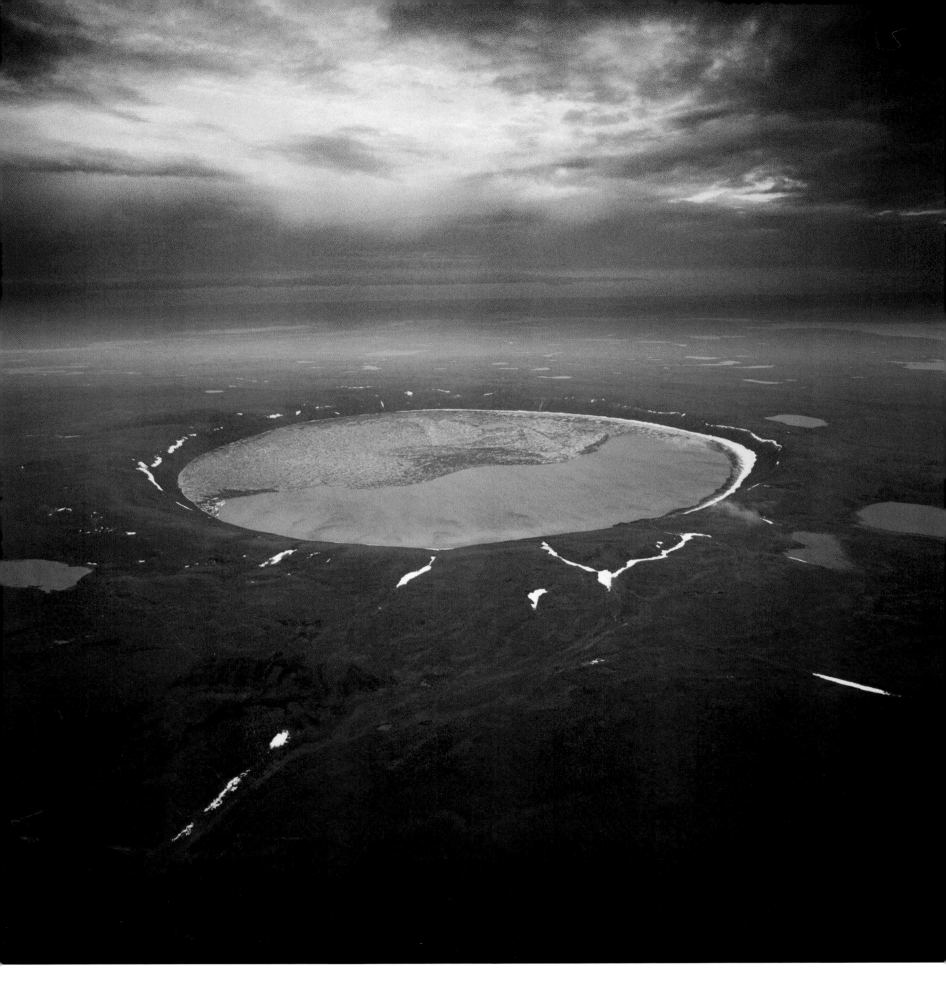

WOLFE CREEK

19°11'S , 127°48'E

Location: WESTERN AUSTRALIA

Diameter: 875 METERS

Crater type: SIMPLE CRATER

Age: <0.3 MILLION YEARS

Geological condition: SLIGHTLY ERODED RIM

Impact evidence: SHOCKED MINERALS, METEORITE FRAGMENTS

Meteorite type: IRON METEORITE (IIAB-TYPE)

Located along the northeastern edge of the Great Sandy Desert, this crater was discovered from the air in 1947. The crater's rim rises 35 meters above the surrounding plain, and its steep inner walls dip 55 meters to the crater floor. Wolfe Creek is one of only a few craters in which, and around which, iron meteorite fragments have been preserved. Typically, the impacting meteorite melts or vaporizes during impact, and even if some meteorite fragments do survive, they are usually destroyed by weathering within a geologically short period of time.

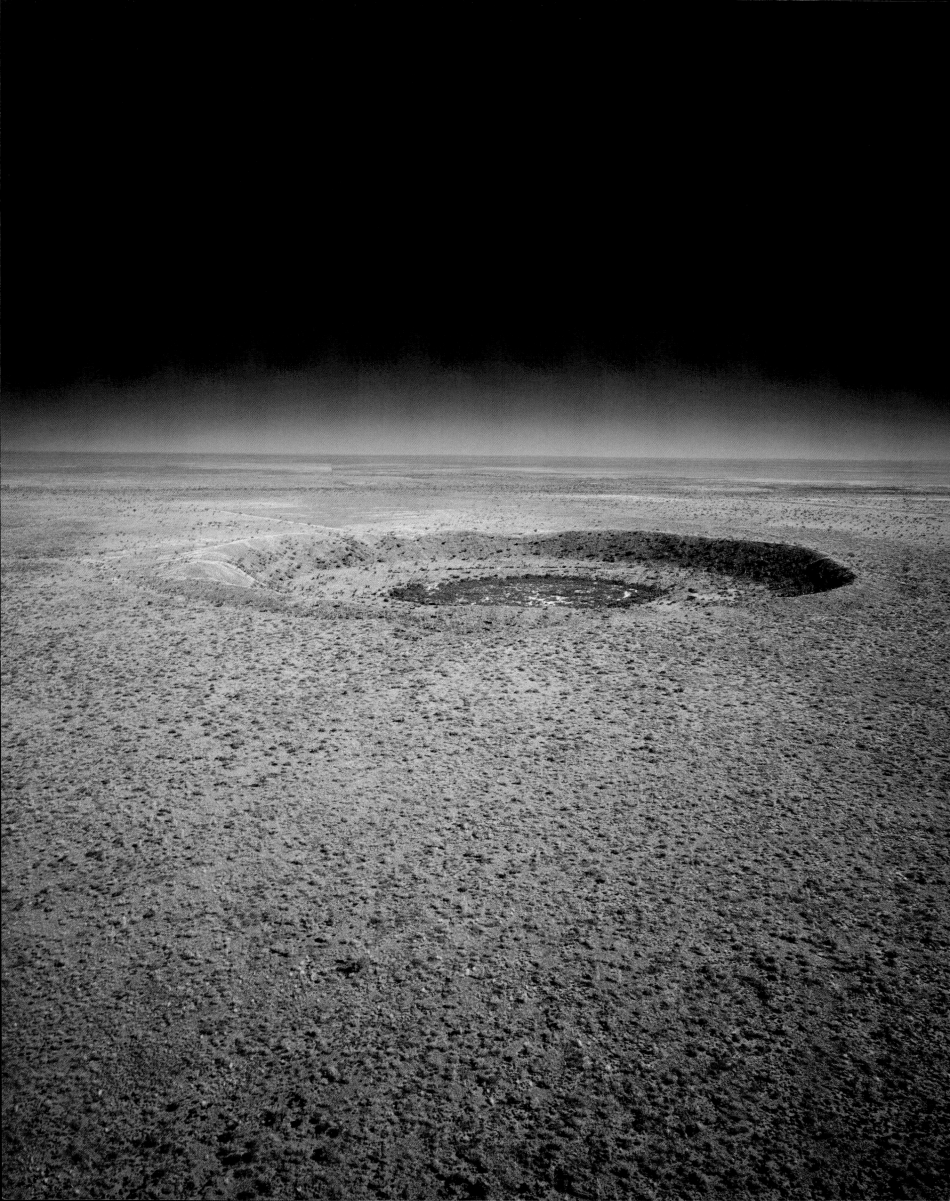

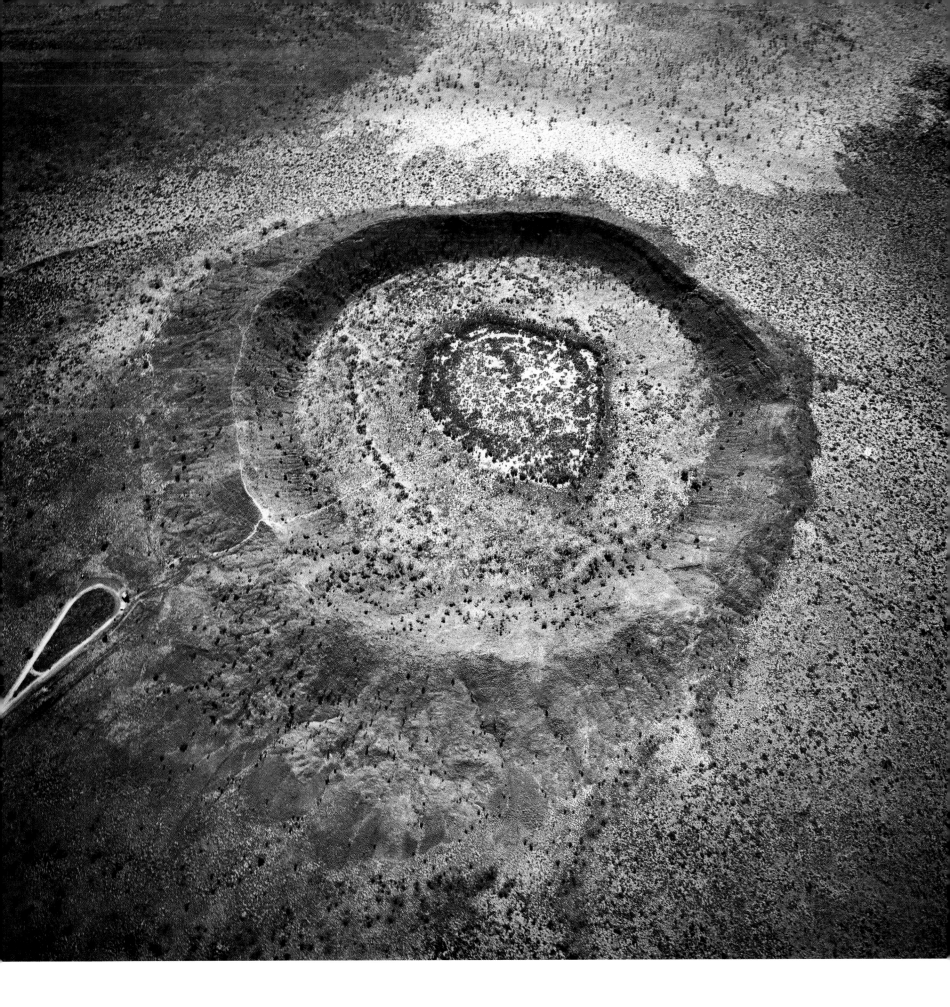

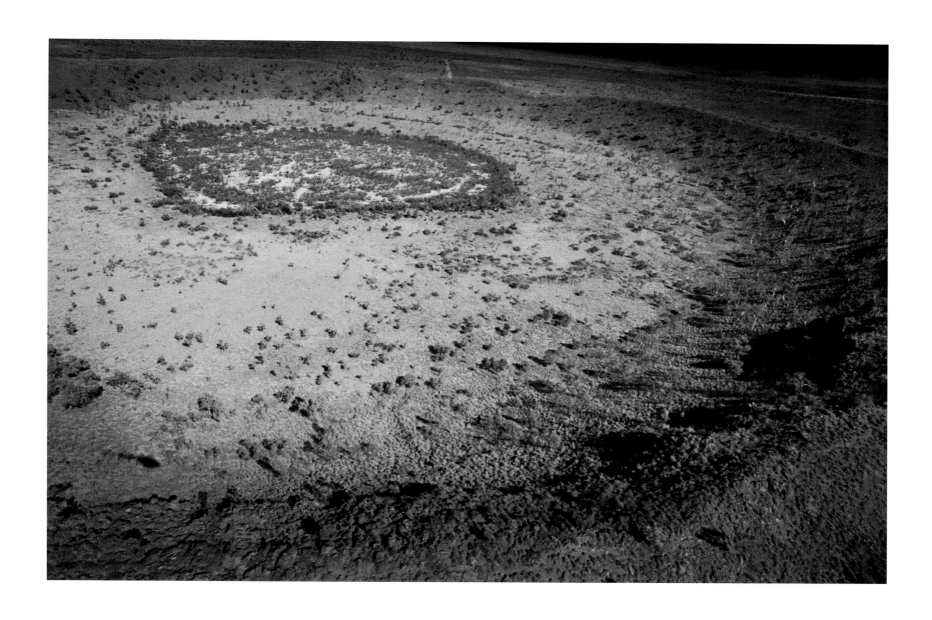

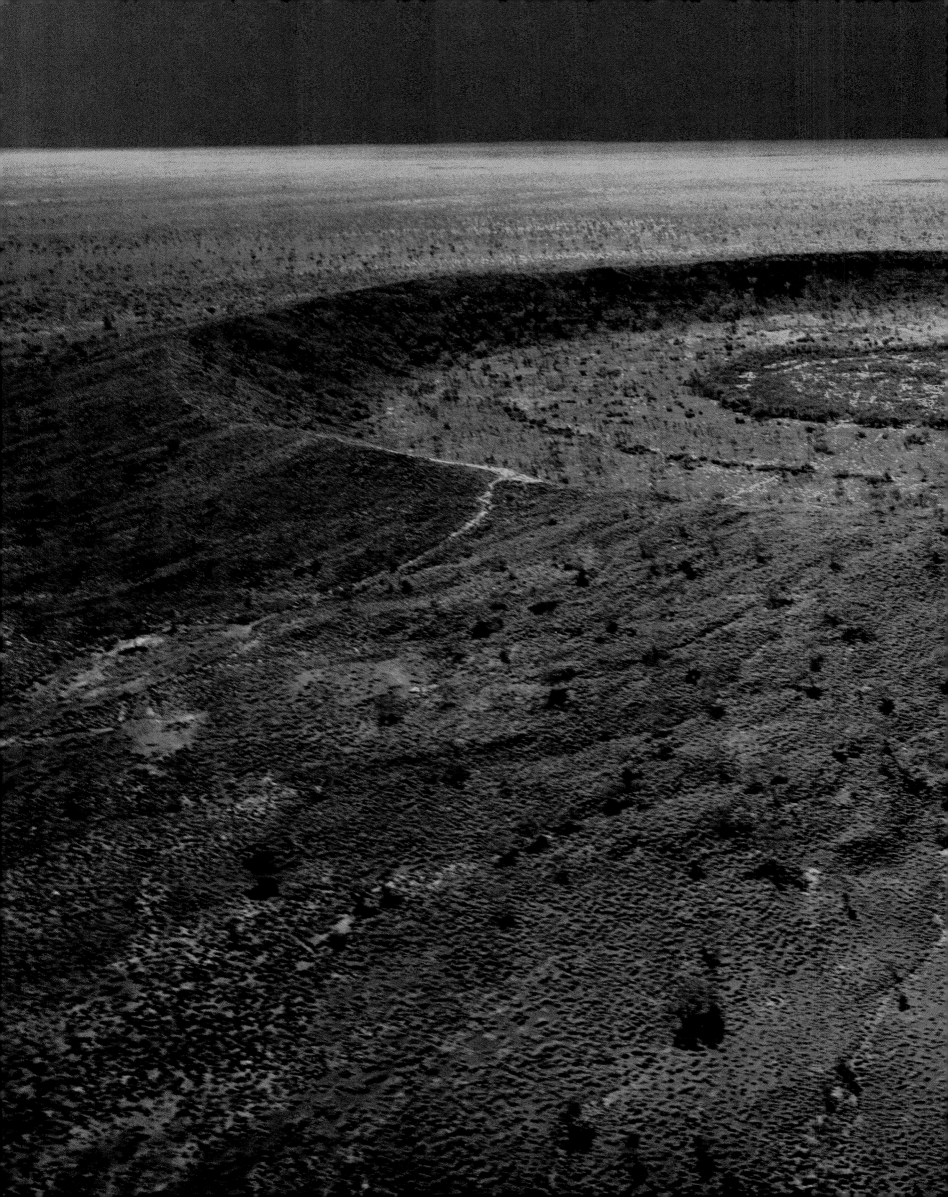

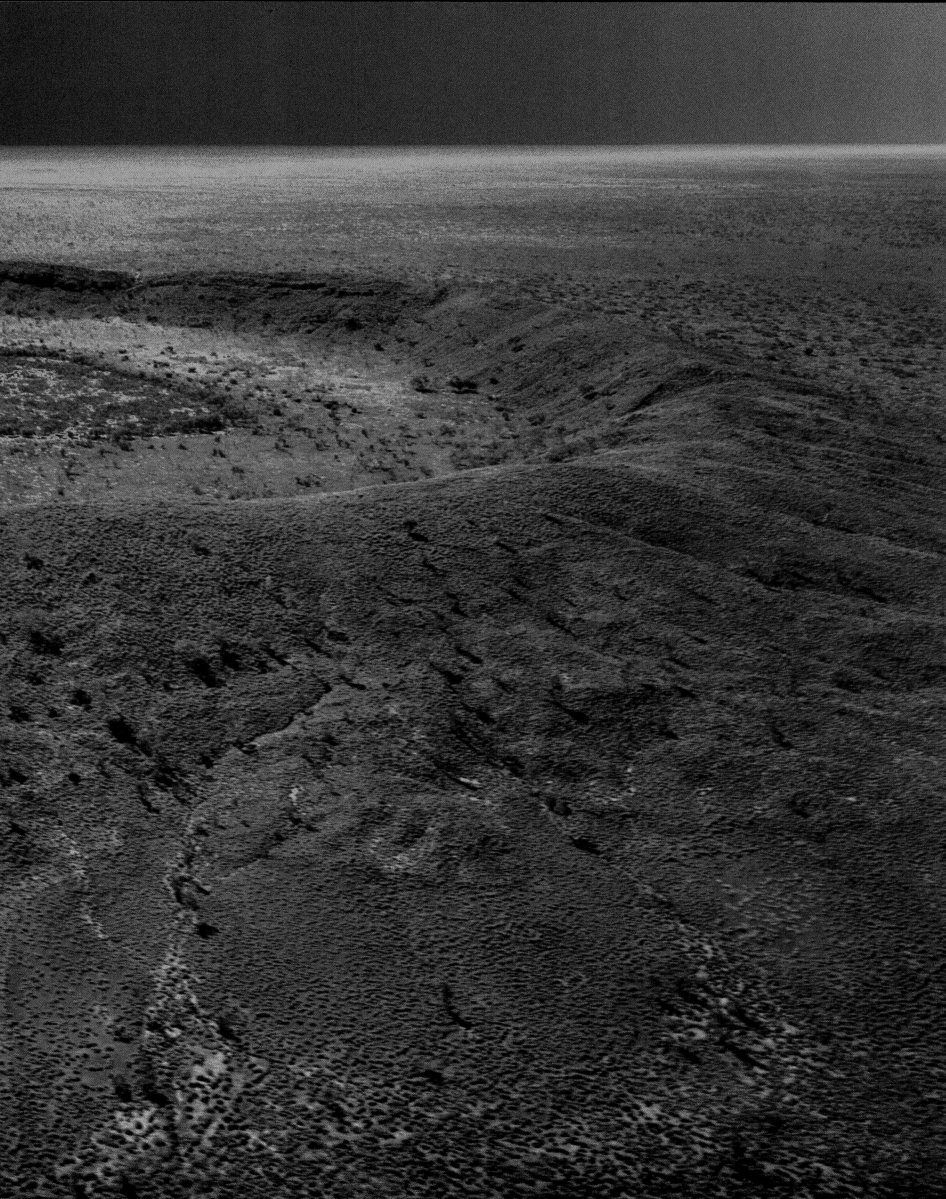

TSWAING

25°24'S, 28°05'E

Location: SOUTH AFRICA

Diameter: 1.13 KILOMETERS

Crater type: SIMPLE CRATER

Age: 220,000 YEARS

Geological condition: SLIGHTLY ERODED RIM, BUT CLEARLY RECOGNIZABLE CRATER

Impact evidence: SHOCKED MINERALS, IMPACT GLASS (IN DRILL CORE)

Meteorite type: STONY METEORITE (CHONDRITE)

Twaing (or Place of Salt, in the Setswana language) is situated 40 kilometers northwest
of Pretoria. It is partially filled by a small saline lake. For many decades it was thought
to be a volcanic structure, because no evidence of its impact origin was exposed on the surface.
During the early 1990s, after drilling through almost 100 meters of lake sediments,
scientists reached brecciated rocks containing shocked minerals and impact glass, thus
providing unambiguous evidence that this crater was formed by meteorite impact.

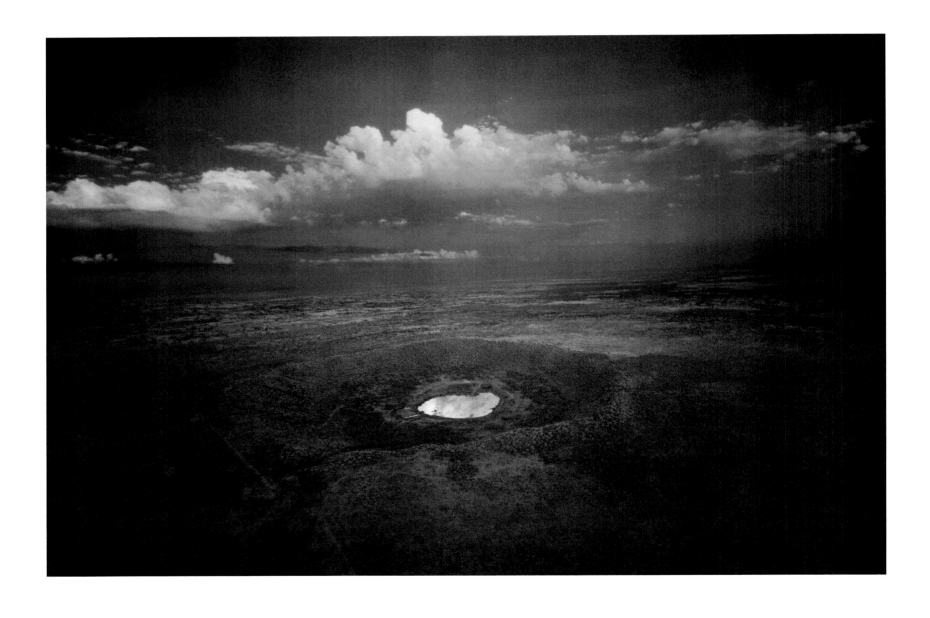

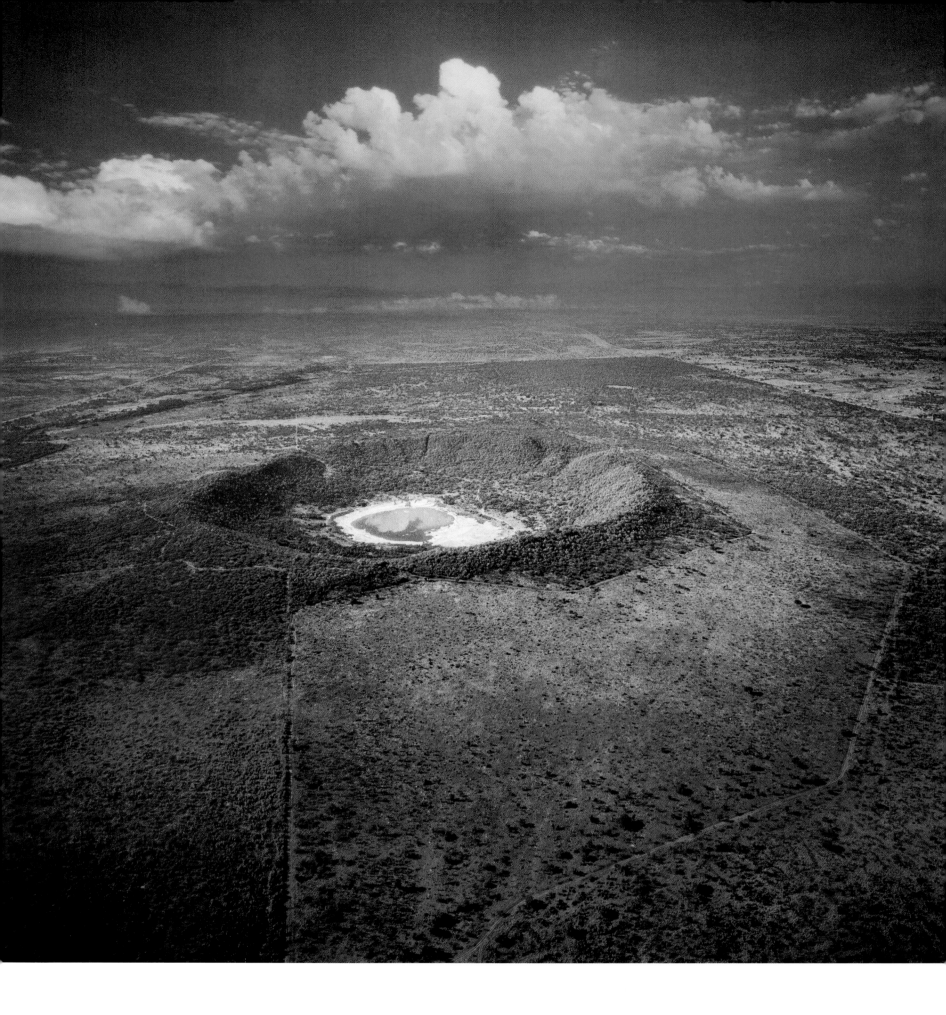

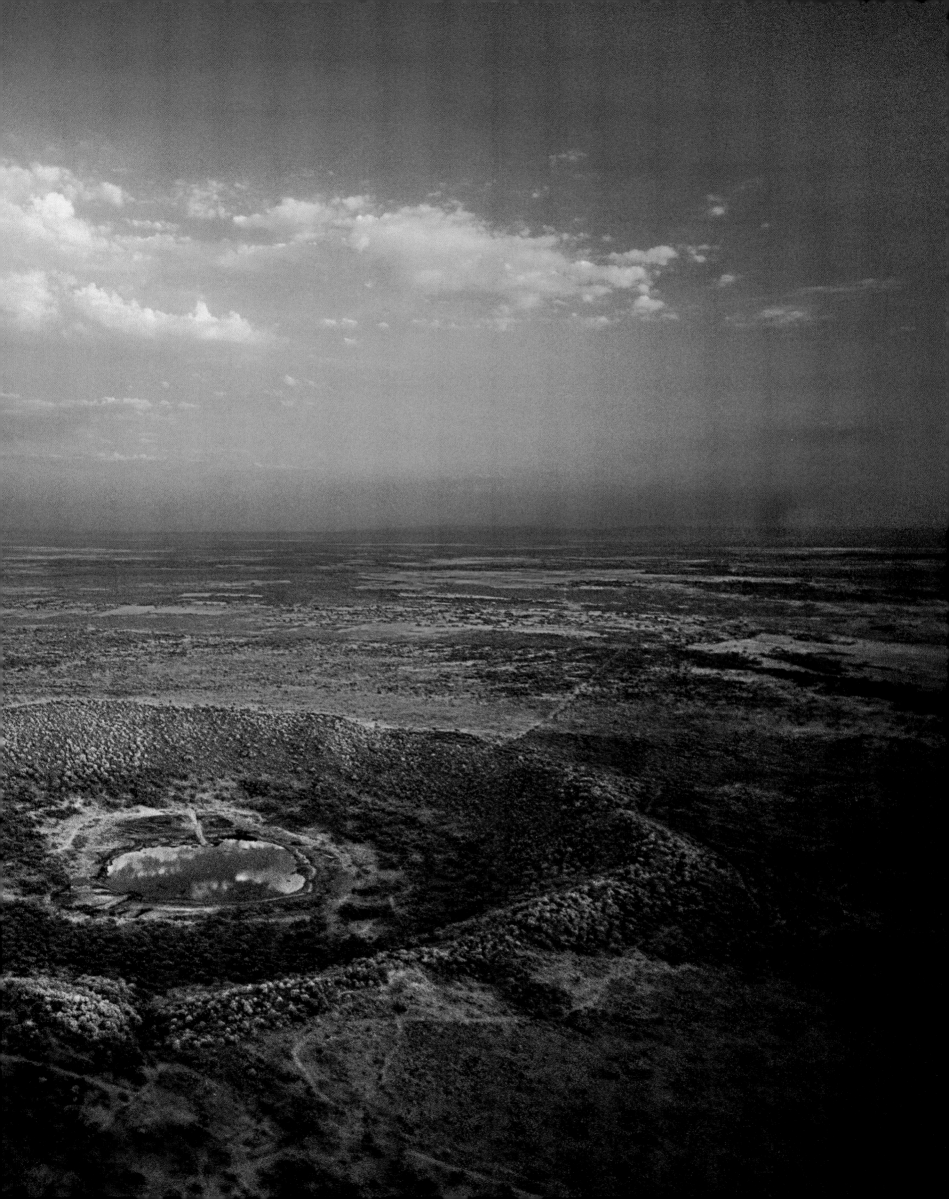

METEOR CRATER

35°02′N, 111°01′W

Location: ARIZONA, UNITED STATES

Diameter: 1.2 KILOMETERS

Crater type: SIMPLE CRATER

Age: 49,000 YEARS

Geological condition: FRESH YOUNG CRATER, IN AN EXCELLENT STATE OF PRESERVATION

Impact evidence: METEORITE FRAGMENTS, SHOCKED MINERALS

Meteorite type: IRON METEORITE (IAB-TYPE)

The importance of this perfectly preserved meteorite crater to the history of recognizing impact structures on Earth cannot be understated. In honor of **Daniel Moreau Barringer**, whose seminal studies of this structure during the first quarter of the twentieth century layed the foundations for much subsequent impact crater research, it is also referred to as **Barringer Crater**.

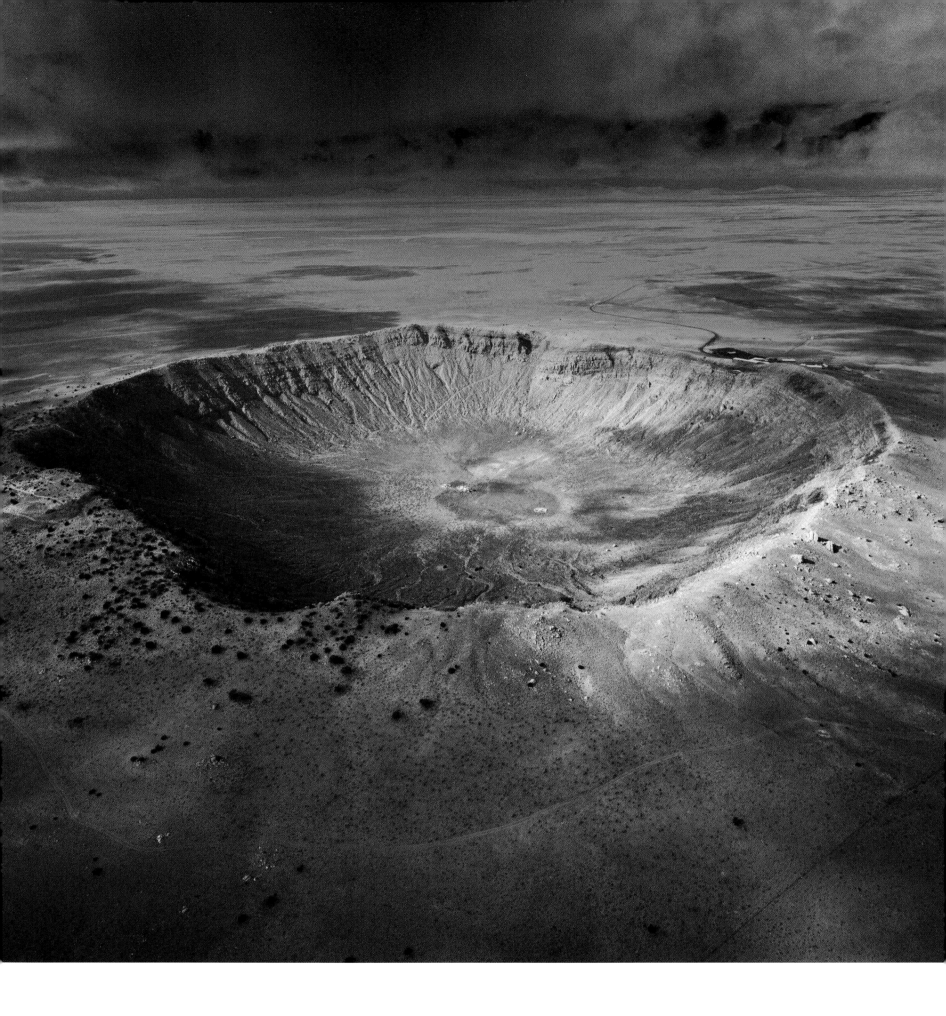

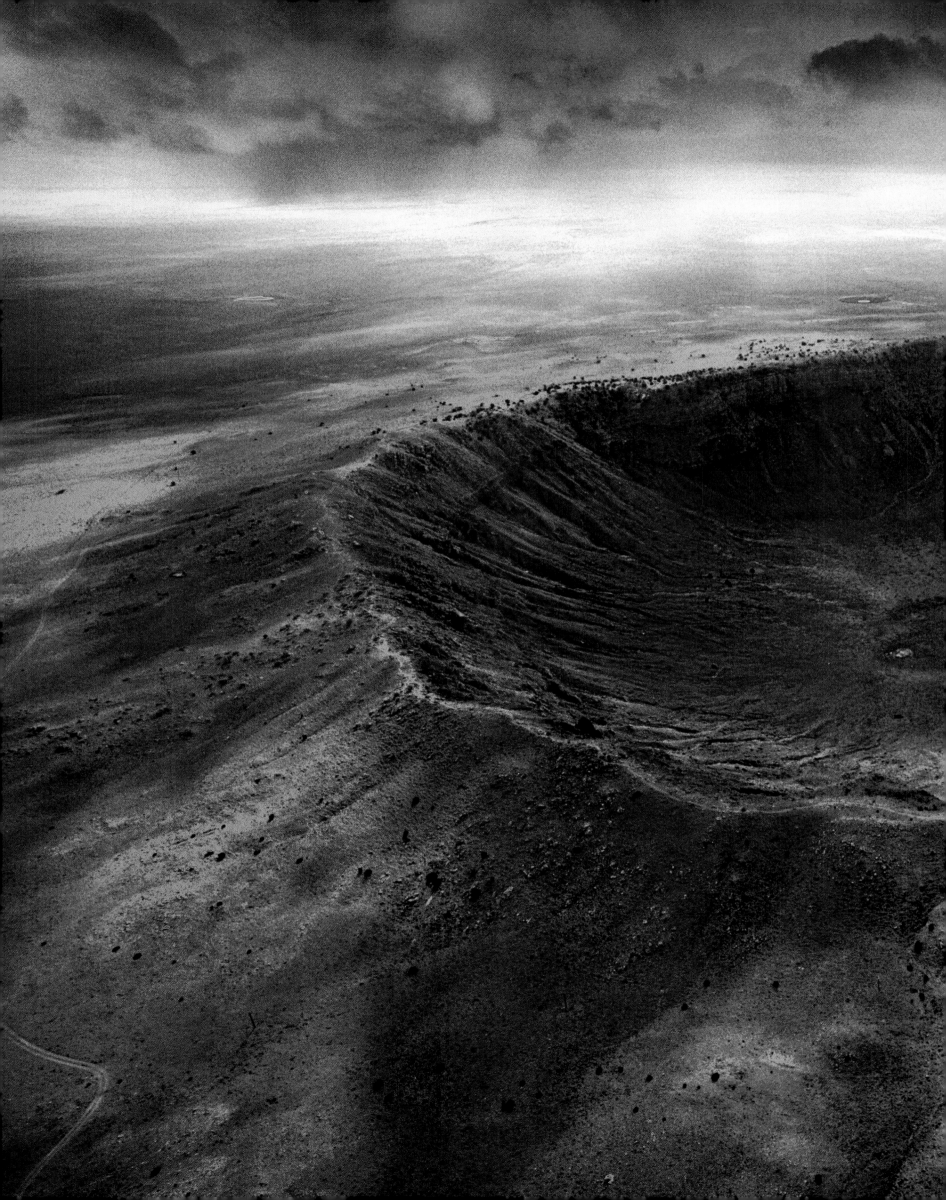

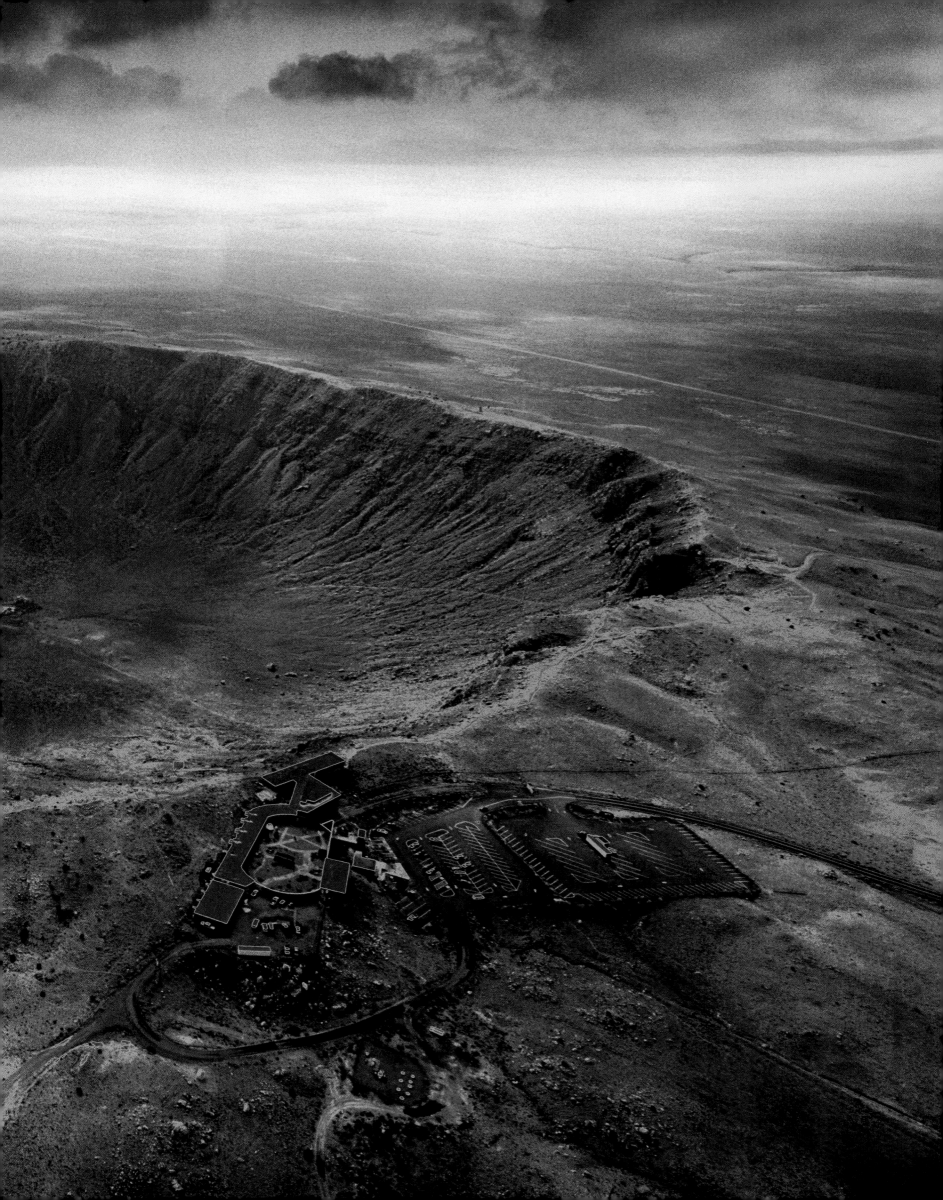

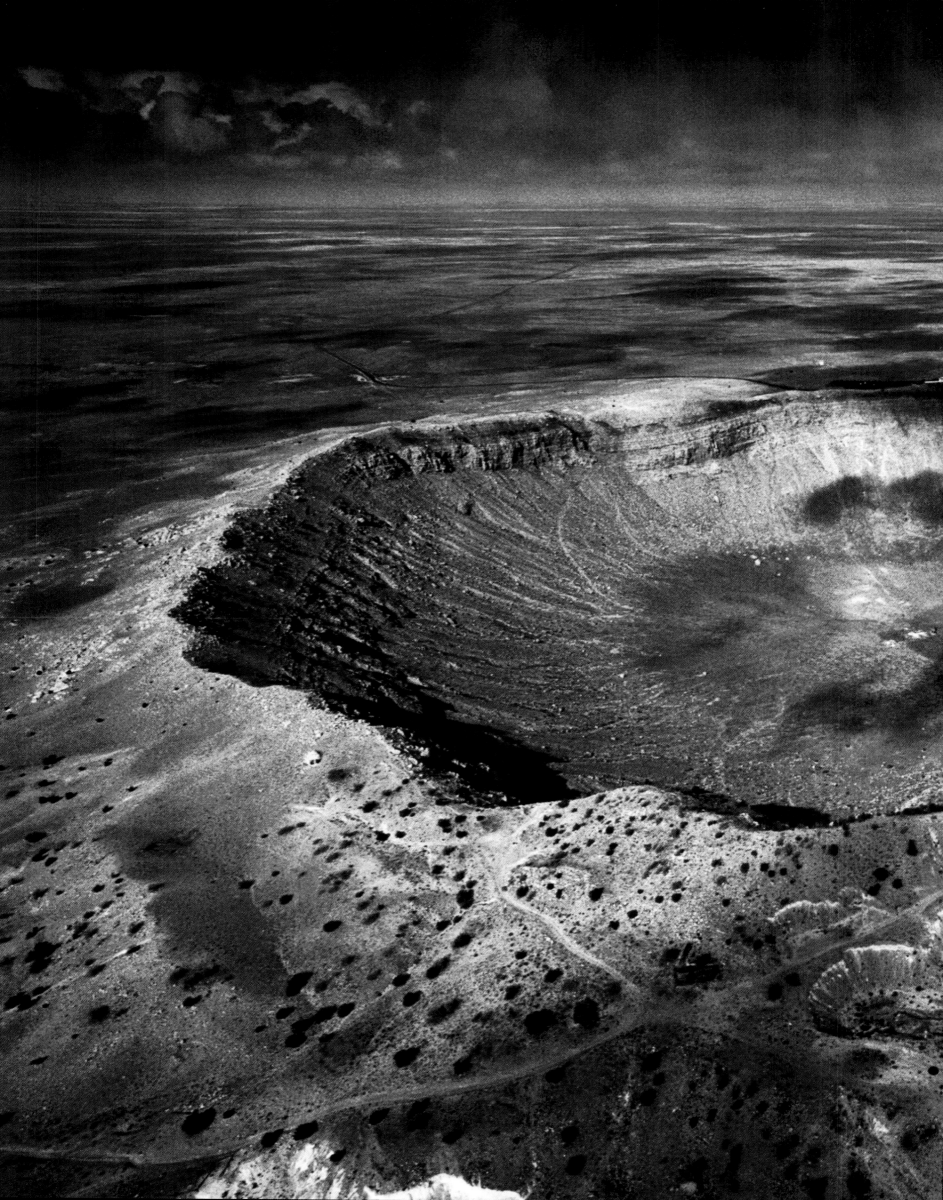

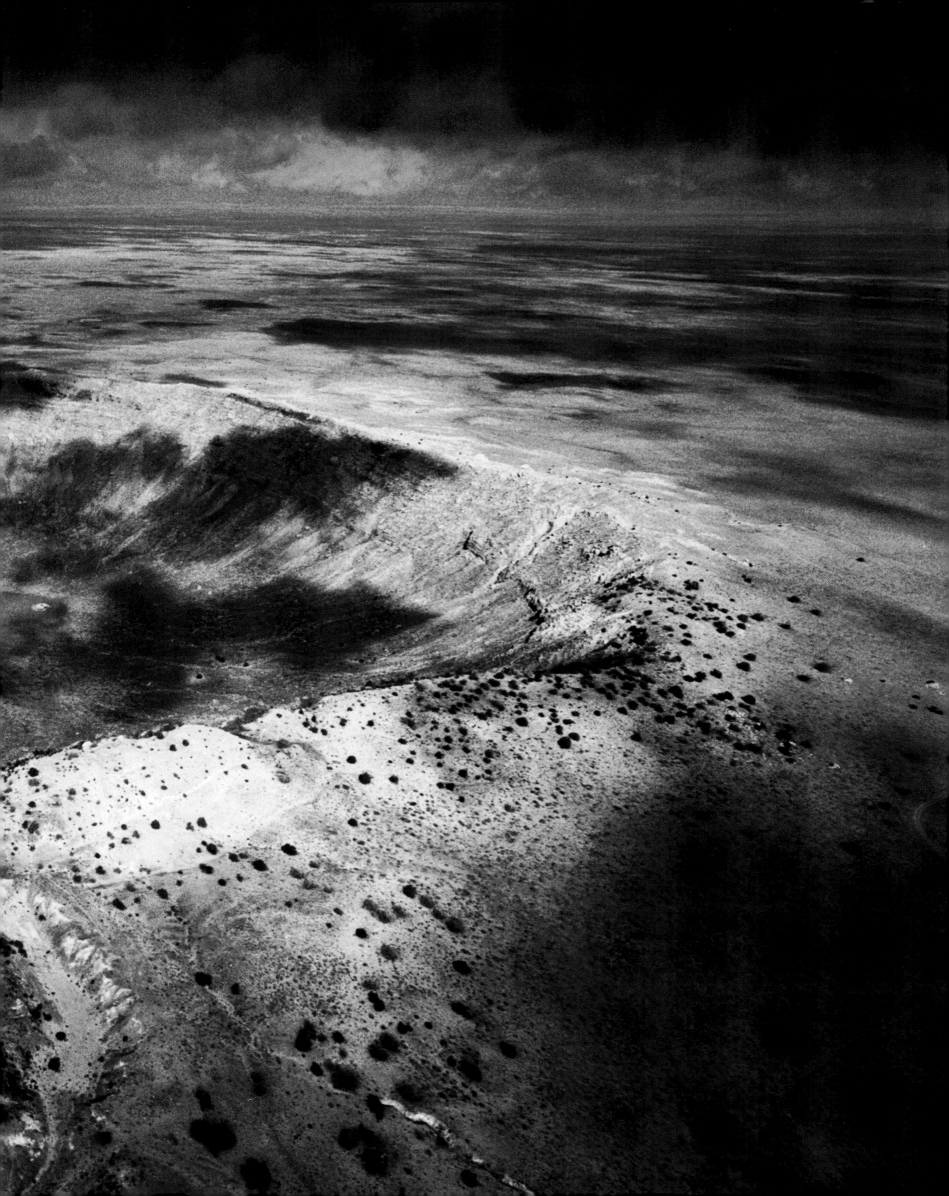

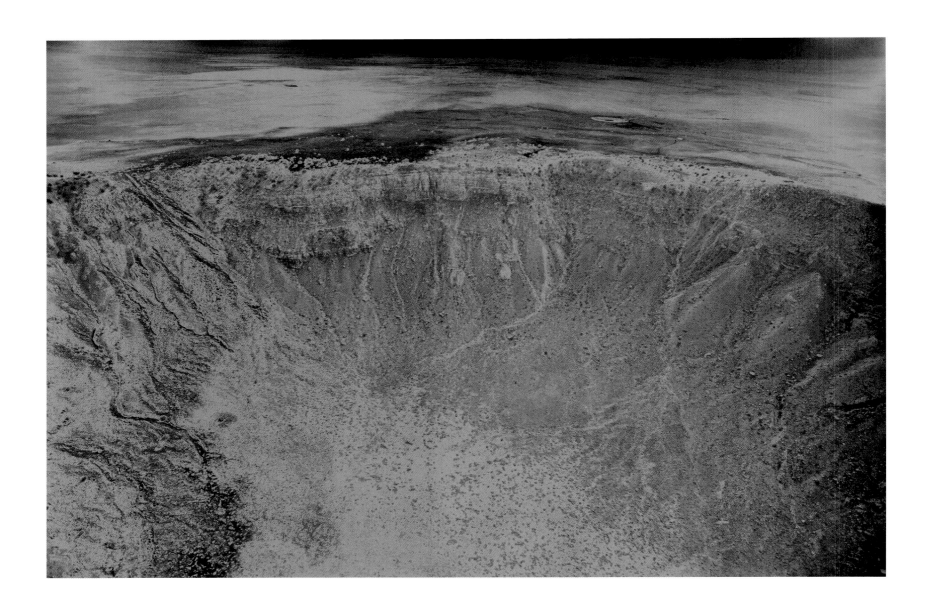

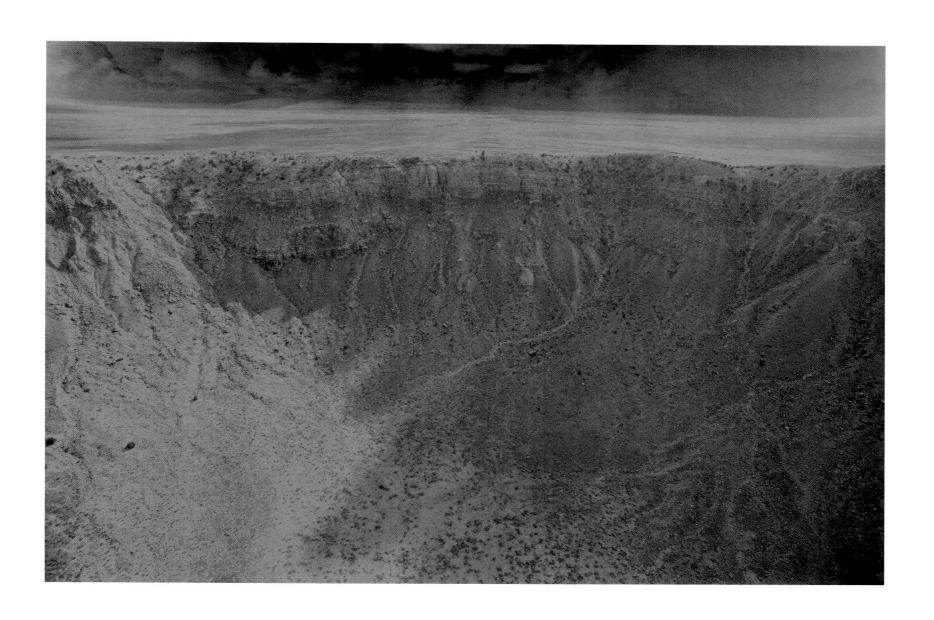

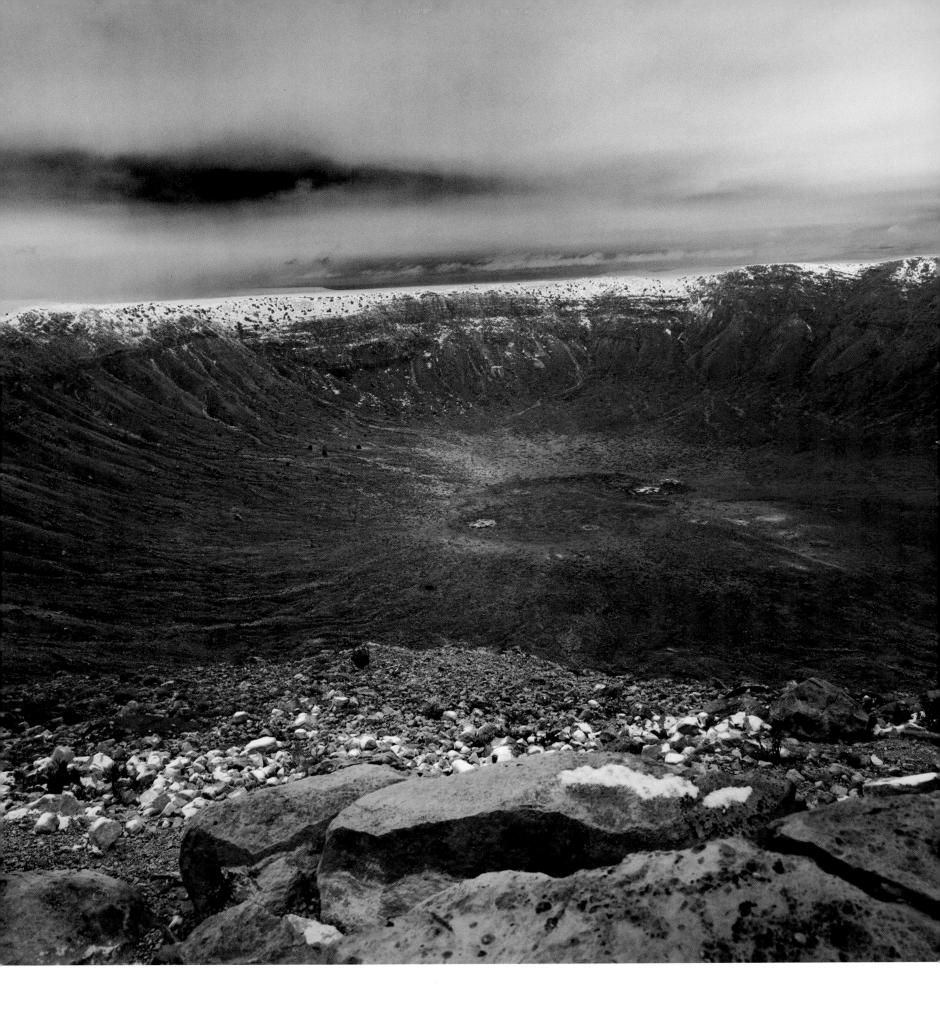

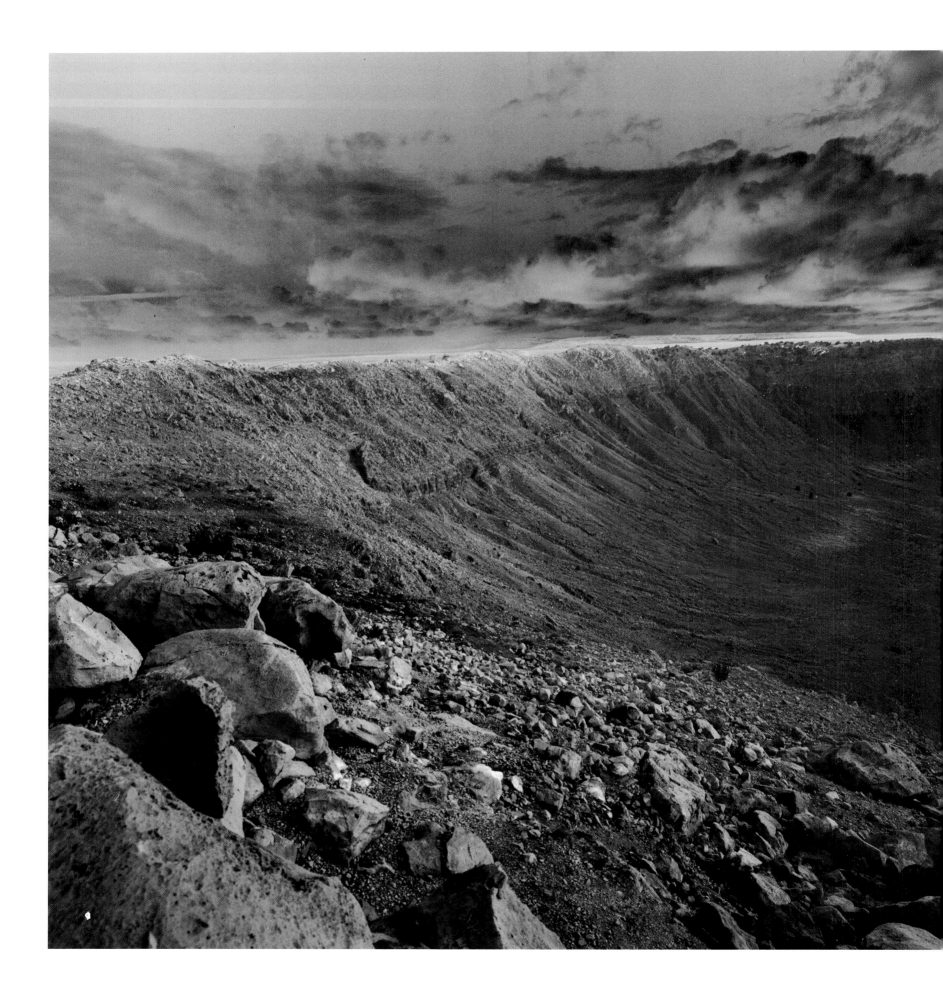

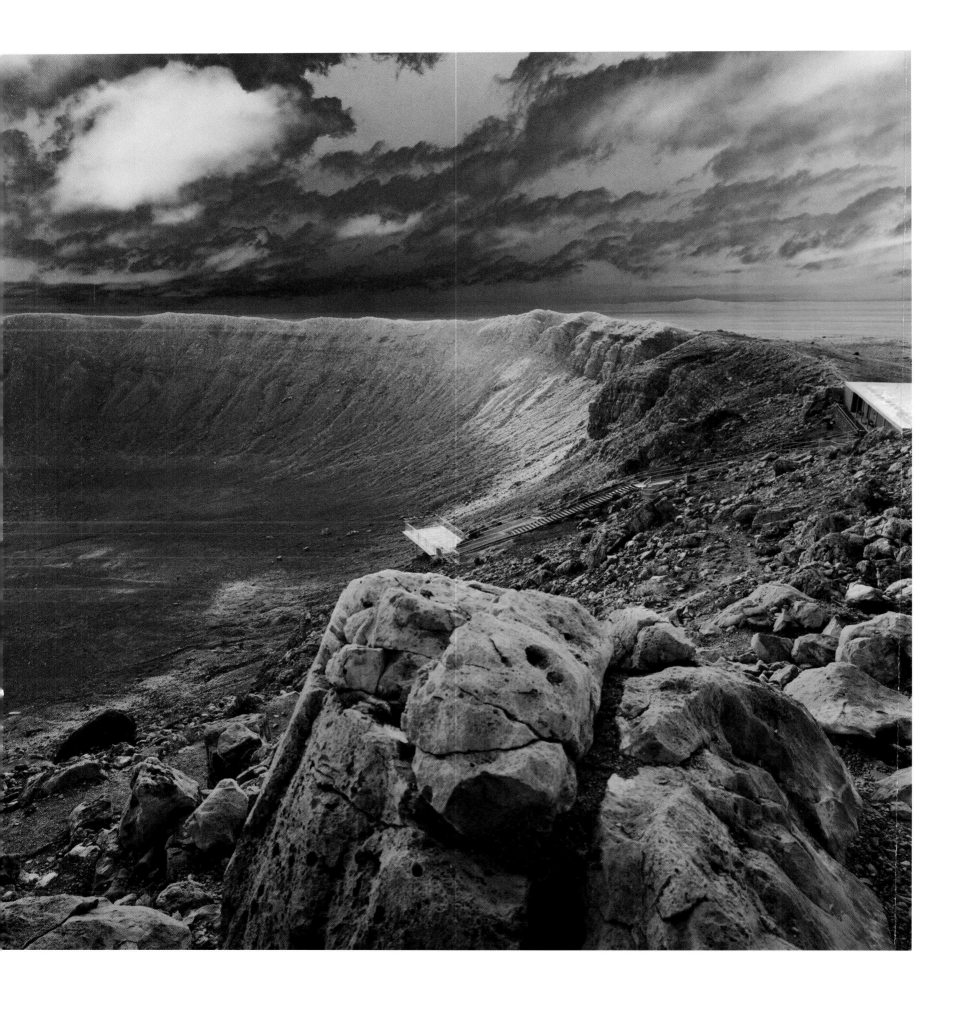

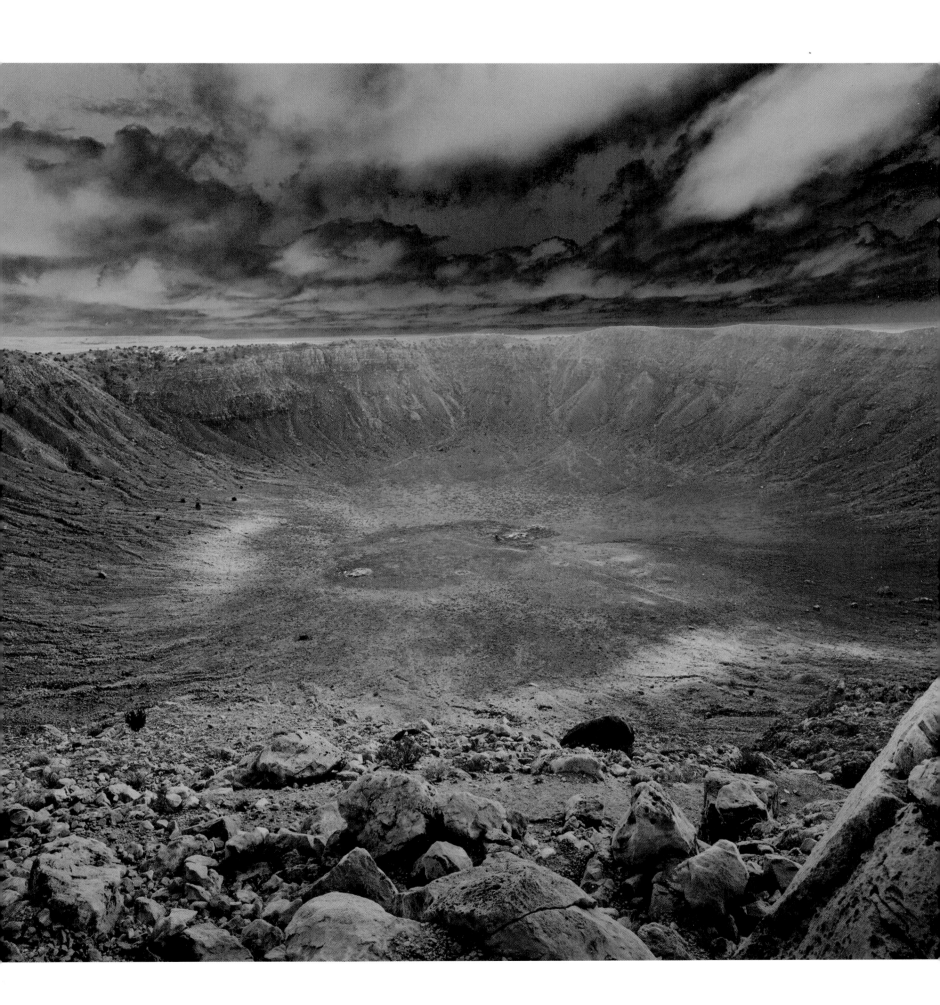

BOXHOLE

22°37'S, 135°12'E

Location: NORTHERN TERRITORY, AUSTRALIA

Diameter: 170 METERS

Crater type: SIMPLE CRATER

Age: 30,000 YEARS

Geological condition: SLIGHTLY ERODED RIM, BUT CLEARLY RECOGNIZABLE CRATER

Impact evidence: METEORITE FRAGMENTS

Meteorite type: IRON METEORITE (IIIAB-TYPE)

This small impact crater was formed during Aboriginal times, and many meteorite fragments have been recovered from the site. The crater rim is raised only about 15 meters above the surrounding plains. Because of its size, it will most likely succumb to erosion within a few hundred thousand years.

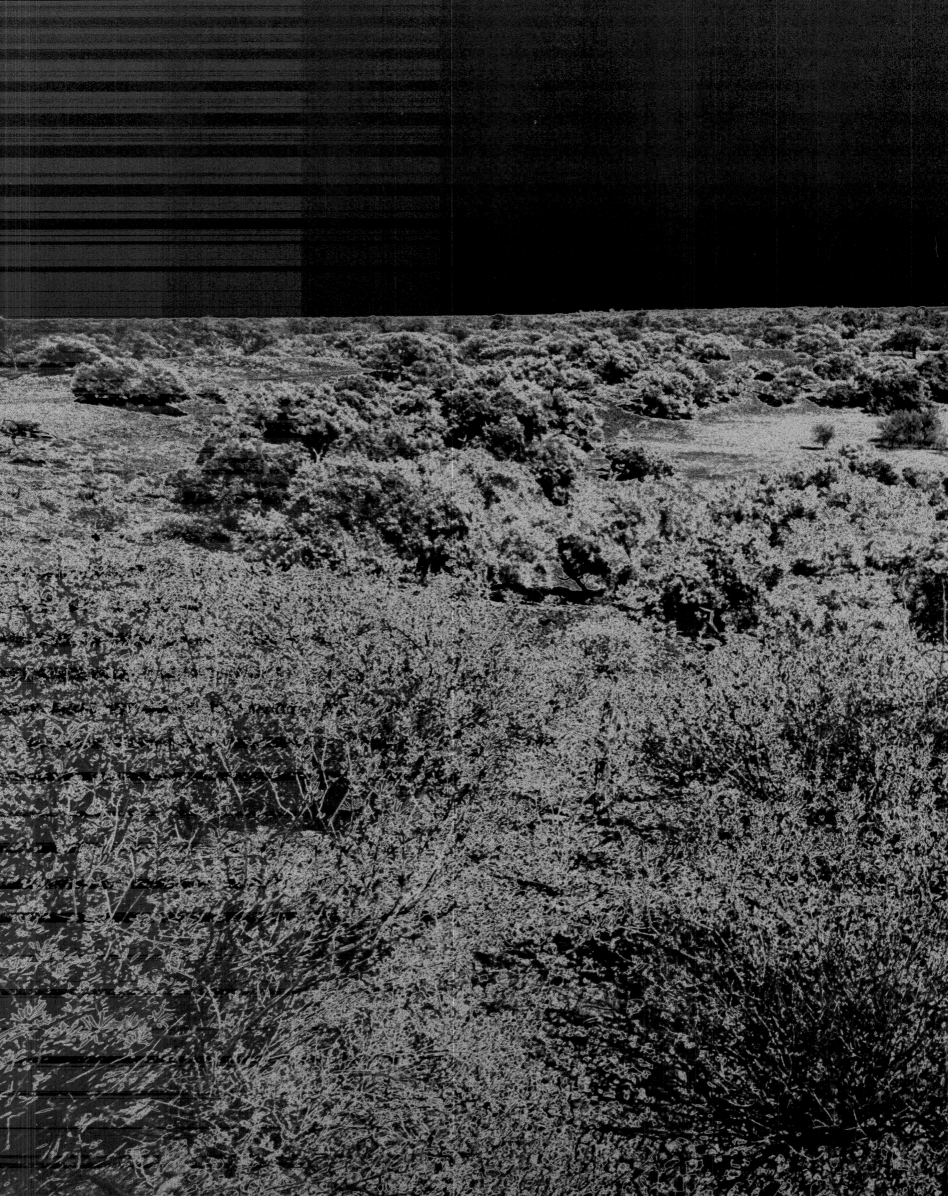

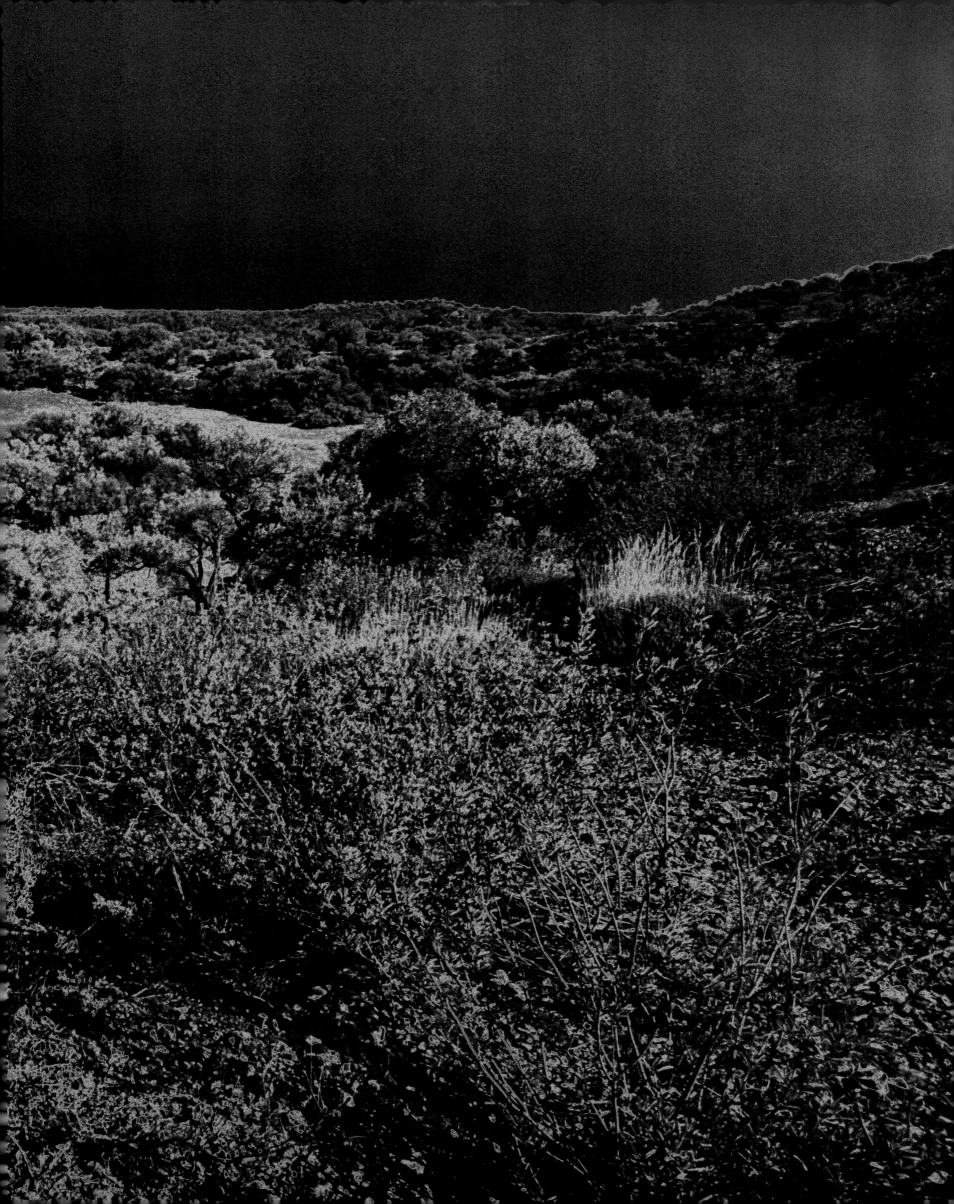

HENBURY

24°35'S, 133°09'E

Location: NORTHERN TERRITORY, AUSTRALIA

Diameter: 0.16 KILOMETERS

Crater type: CLUSTER OF SIMPLE CRATERS

Age: 5,000 YEARS

Geological condition: YOUNG, BUT ERODED

Impact evidence: METEORITE FRAGMENTS, IMPACT GLASS

Meteorite type: IRON METEORITE (IIIAB TYPE)

The Henbury crater field encompasses about thirteen craters, ranging in diameter from approximately 10 to 160 meters and scattered over an area of more than one square kilometer. The individual craters are thought to have formed approximately 5,000 years ago, when a large iron meteorite broke into pieces just before impact. Studies of the remaining fragments were undertaken in 1931. The craters have been eroded over time, and several are now just shallow depressions.

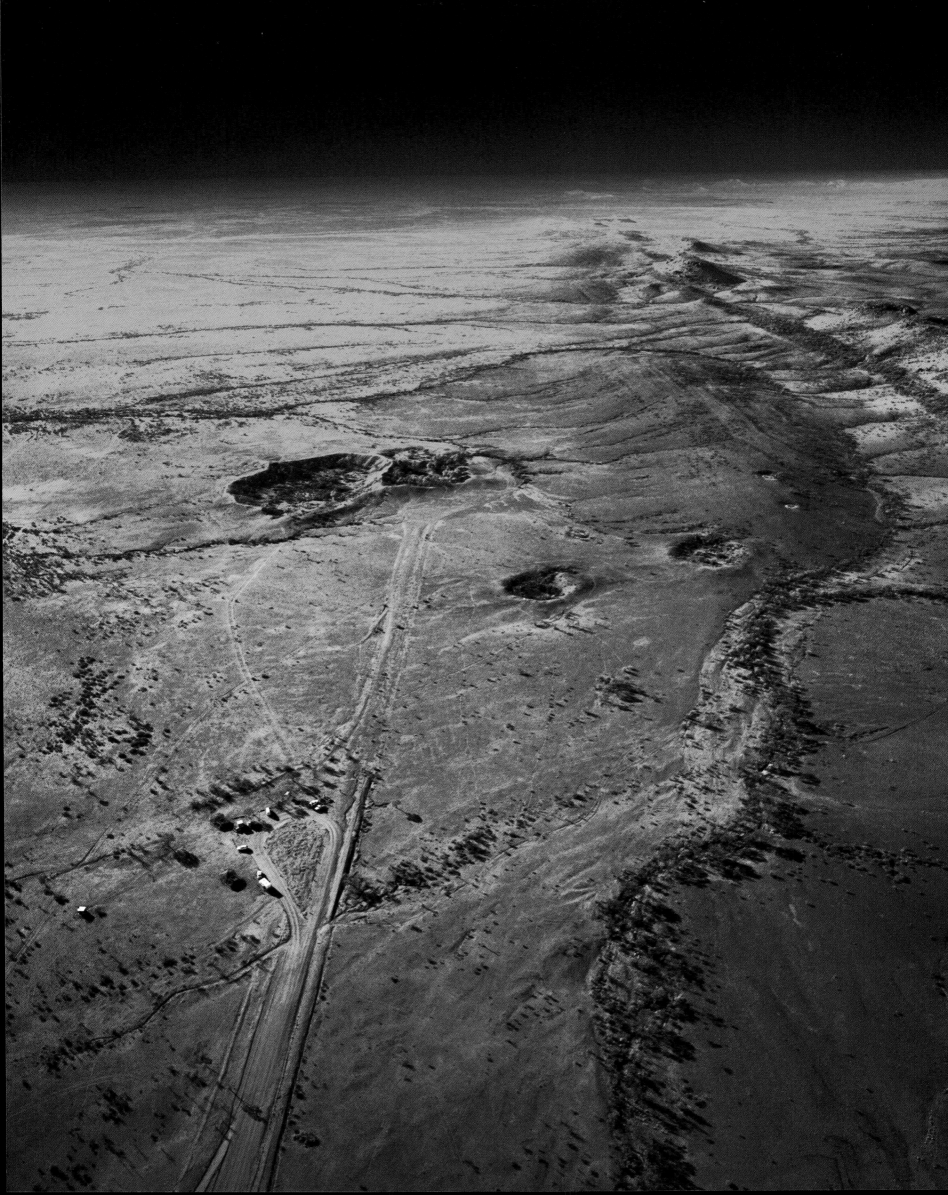

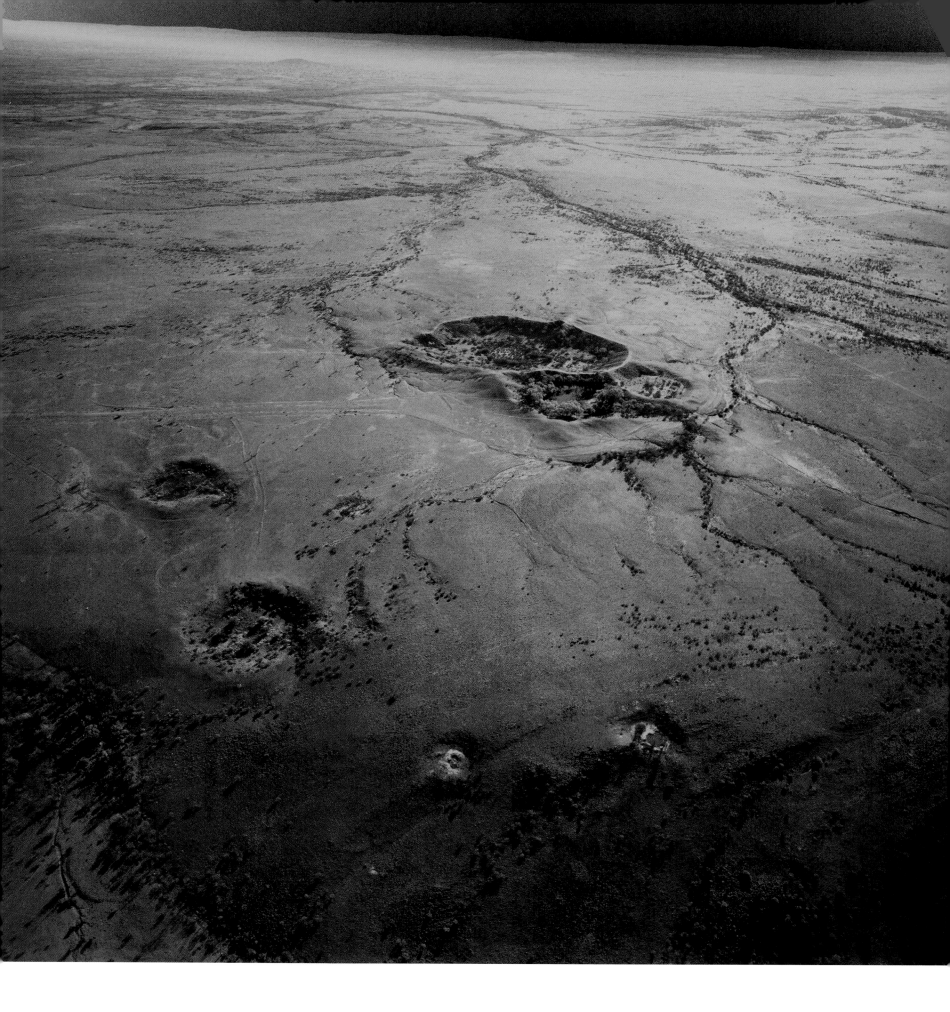

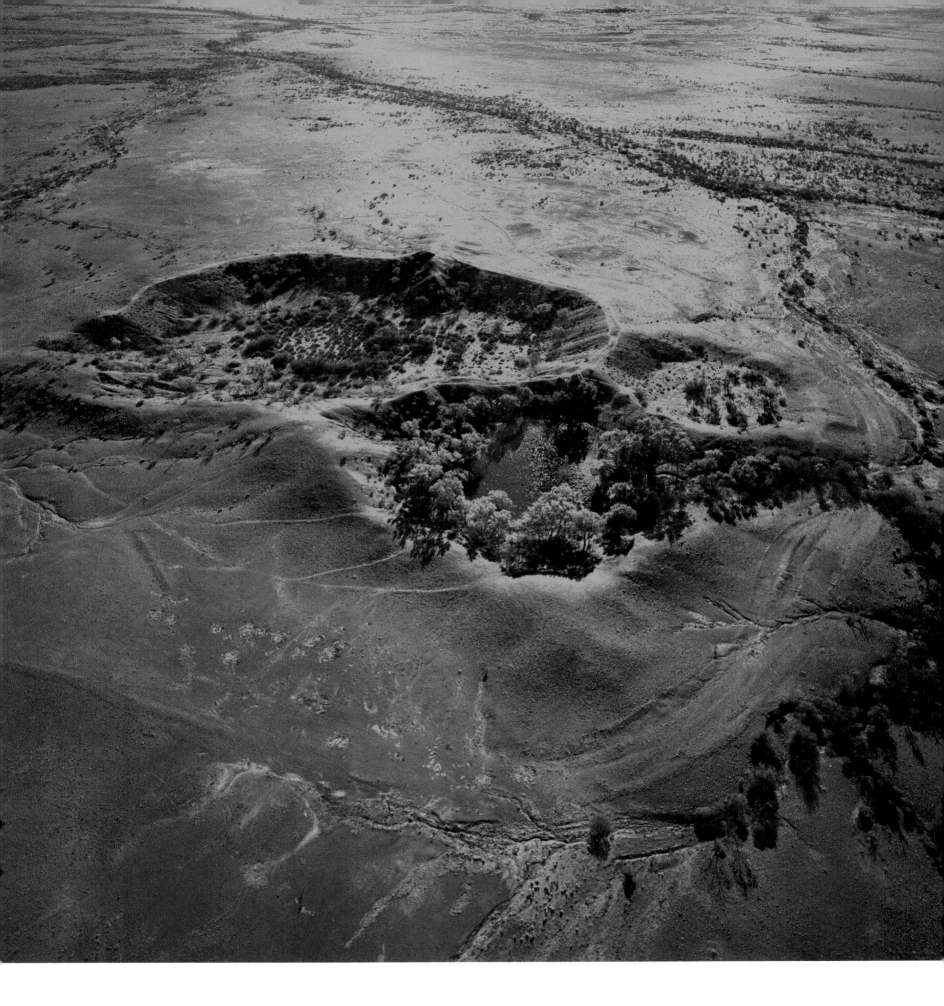

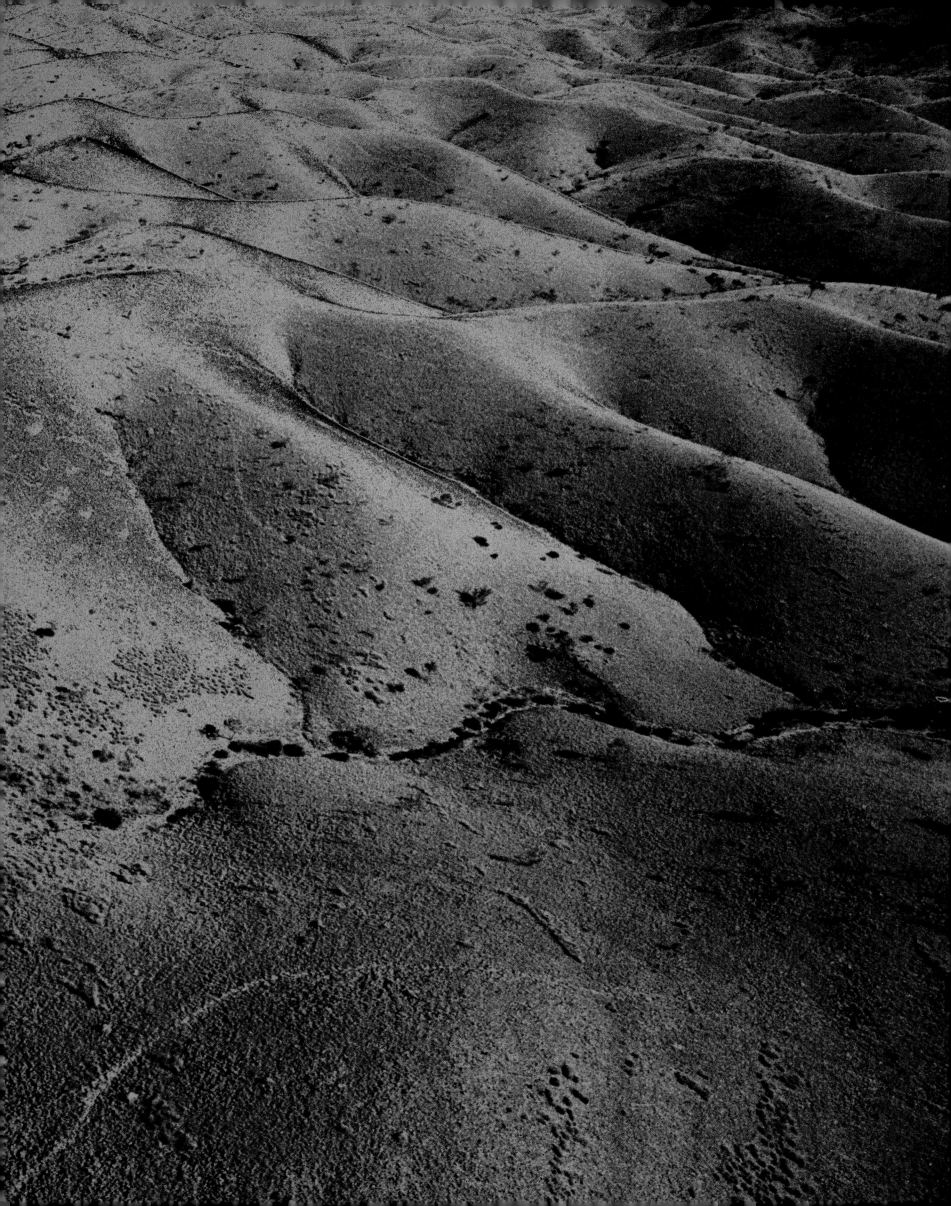

About the Authors

STAN GAZ is an artist who works in the media of photography, sculpture, film, and performance. He lives in Brooklyn and is represented by ClampArt in Chelsea.

CHRISTIAN KOEBERL is a professor at the University of Vienna, Austria, where he concentrates on interdisciplinary studies of meteorite impact craters. He has led several international research projects related to impact cratering, has published widely on the subject, and is the recipient of the 2007 Barringer Award for outstanding work in the field of impact research. He also has an asteroid named after him.

ROBERT SILBERMAN is a professor at the University of Minnesota, where he teaches film studies and the history of photography. He served as senior advisor for the 1999 PBS series *American Photography: A Century of Images* and, with Vicki Goldberg, coauthored the companion volume.

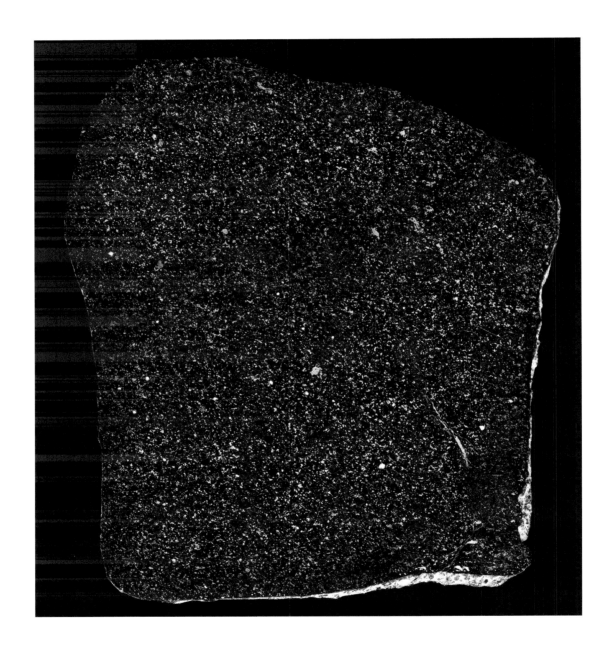